SOFTLY THEY CHEW THE CUD

NEW POEMS & POINTELLE

BY

MARK WHELEHAN

Tyresmoke CPP Ltd
10 Sandpiper Gardens
Chippenham
SN14 6YH

CepenPark Publishing

First Published in Great Britain in 2022 by CepenPark Publishing
an imprint of Tyresmoke CPP Ltd
© 2022 Mark Whelehan

Mark Whelehan asserts the moral right to be identified as the author of this work, including all text and images, except for the photo on the rear cover which is © Paul Timlett and is reproduced with his kind permission.

A catalogue record of this book
is available from the British Library
ISBN 978 0 9564230 6 1
Printed in Great Britain by

CPI Antony Rowe
Units 1-4 Pegasus Way
Bowerhill Industrial Estate
Melksham, Wiltshire, SN12 6TR

Scanning: Dave Springford and Steve Sawyer, Springfords & Rose Ltd, Devizes

FOREWORD

The shackles have come off after lockdown. Reclined in an old punctured armchair before the shed on my plot of land, I watch two buzzards rule the thermals, circling above while Crook my Great Irish Wolfdane, sated with a pasty and cake has given up and rests his great big shaggy head across my outstretched legs.

Cows. Ignored in art to a large extent they, to me, are an integral component of the pastoral symphony. Words have been lean of late but on demand are back, flowing softly as the stream does in a sense, revitalising and cleansing my reticence of theme and I can dream that the end justifies the means.

And in this time of great upheaval I am still beavering away, carving shapes from fallen trees like a woodpecker, relentlessly knocking on wood. It seems absurd with all the alternative materials in the world but books, art, it's all still there to pick up at will, read or look at, a testimony to every tree gone now, yet still in pages here - words out of wood, pumped out of pulp are constant, living in and out of our forests.

In those words I would like to thank:

Paul Wiggins and family - my lifetime friend, for his continuous support and perseverance, searching out the inevitable typos with great tenacity and humour.

Mimi Kellard for her kind drawing of the Orange Tip butterfly - lovelier in colour!

Eternal gratitude to my Mother, all my family, Crook, Dolly and t'other pets and friends. Last but not least Peter Harris & broom, from Crookwood Farm, in his fidelity to duty, for "Shooo!"-ing my recalcitrant peacocks back to me.

MARK WHELEHAN

Other Books by Mark:
Cassiopeia Lying Eastward (2017) - ISBN 978 0 9564899 5 1
Dawn Sail over Crookwood (2019) - ISBN 978 0 9564230 1 6
Sailing With Ó Faoilleacháin (2020) -ISBN 978 0 9564230 5 4

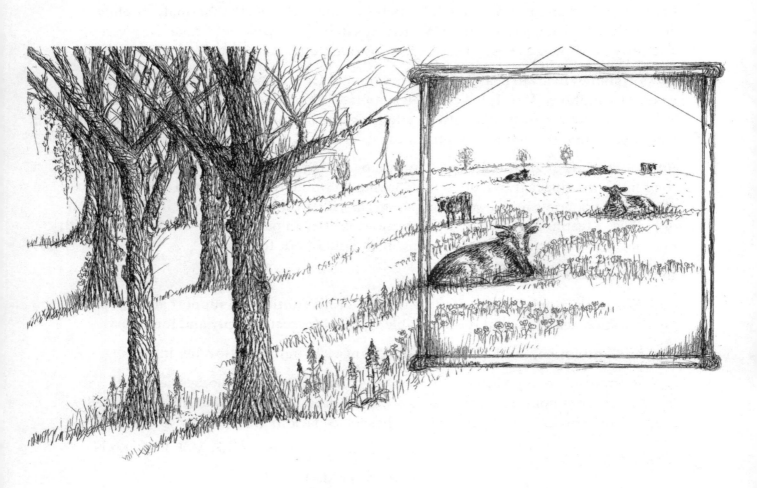

SOFTLY THEY CHEW THE CUD

Cattle lowering their voices heard
Reveals the dropping dusken breeze
And lifting their hollow heads at last
Only now pronounces a warbling of the brook
Their ripping chomping rasping tongues
Curled up in their muzzles till the morn
Like Turk's heads in their sheaths
Their silent words to cook

Forked tongued the lisping grass snake feeds
Her eyes flashing in the darkened day
I catch the vapour of her squeezed
Beneath the corrugated sheet
Sneezing in her bed of hay

Softly they chew the cud
Piebald cows in silent file
Pilgrims hiding their beliefs
Like forked dung for roses sweet
Their future workings slap the floor

I watch them walk their own well-trodden path
Until they are no more
Sloping off over the horizon below
The shoons of an early moon's footsteps
Sliding into earth along their lime lit way

Although the sun still burns
A crease atop the slope of purpling green
And though I can follow them whenever I please
I choose to stay here roosting preening
My plumes and thoughts
And dream
I am an angel
A sort of bird

I see them escorted off unto
Their byre their mired hollow
Plagued by swarms of buzzing yellow
Flies massing about their tails and eyes
And where no one should go
They turn and bite

Bucolic caravan unfractory
A mobile milk factory
Followed hungrily
By nodding jackdaw and swooping swallow
All this daisy chain disappearing over the top
Like a lost train of sweet sorrow

Yet I remain instead
Sane patient and relaxed
Rooted to the spot inside my bed
I find no need to emulate the baying crowd
I can eat tomorrow and
Quietly not out loud
I am an angel bird
Maybe with an alien head

MARK WHELEHAN

NOT READY YET

There is a figure waving
As I wave back
Sometimes another joins the other
I cannot see them clearly
But they are black

Black figures waving
Recently it's all the while
Sometimes it makes me smile
Their guile
Sometimes not

Steadily from left to right
Waving in plain sight
Dark figures seen in the day
Not seen at night

They make no sound
No call or shout
I can't work out what they're about

They're beckoning me to join them now

But I turn to go as I did before
Coz
I have a few things to do here
More

AND THE GREAT BIG SAD FACE OF MEMORY

And the great big sad face of memory
Rumbles slowly across
My inner place
My inward eye watching
It grooaans and aches in the time it takes
Dissolving eventually in the instant open air of now

... and below and above is all it makes
And the thousand of keepsakes
Free runs and line breaks
So much my mind fakes the eternity
Of it all

I lie back in bed
With my red hands wrapped round my blue head
And I ask myself is it really true

But I am miles away
With my mind glued to

The mournful song of a morning thrush
Just before we all rush
At it in the day
As this old sleeping boar lays
Damp with dew

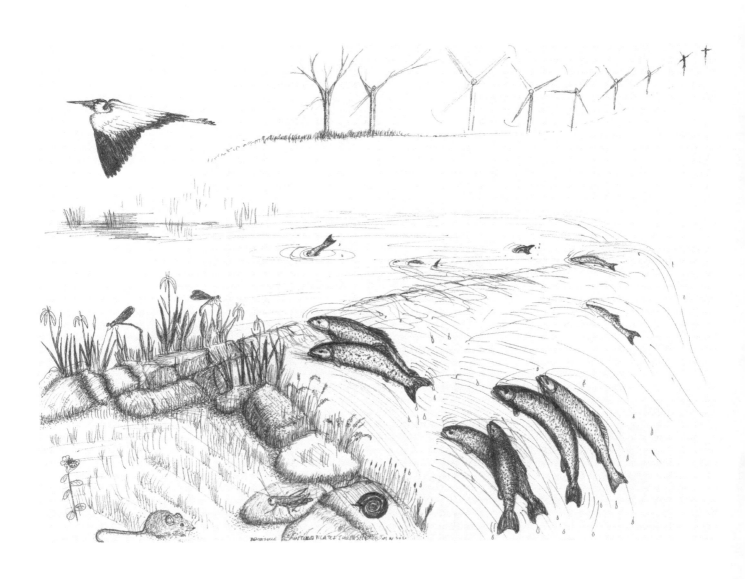

A TRAIL OF TEARS

Rain rain rain rain
Precipitates lamenting drips
Rain is creeping down the scree
Slips mountain sides sea level dives
Sweeps southward slides down
Trodden ancient droves ...
The whole land lies like covered loaves
Wet sheets of mist o'er plastic rolls
A freak cold unseasonal kiss ...
It pours it's hiss

A warbler creeping through the gears
Omnipotent it hides its fears
In feathers tightly shut
It drops
And as my engine roars
Sends it into 'pause'
I take my right foot off the throttle
I 'd rather watch it vole-like scuttle
And listen charmed delicious
Throstle
Mistle- toed and honey suckled

The sun will shine another day
So it must just keep on its way
It hops about inside the hedge
Paranoia? ... on the edge?
I watch it edge towards some fate
Counting the cost?
Maybe a nest of fledglings
Lost?

No let up the rain is lashing
My girlfriend's pulling up her leggings
Coat caught on the gate chains
Huffing puffing ...
I turn to call to hurry up
I can't repeat the bloody stuff
She struggles as we can't be late
I turn back
The bird has gone
But still I hear its lonely song
Drifting fainter all along
A trail of tears
Behind it's song

MNEMOSYNE

From my desk I look out and up
Through a sad old paned window
Puttied up
At Uranus and Gala
The silver crescent moon winks
A frosted eye
A bullfinch sat fat in a cherry tree
I hear its enigmatic wheeze
Plucking petals as it pleases
To get at scrumptious buds
It teases then freezes

Sharp like a sliced doubloon now
Its face placed
Across the moon there flies
The icy air in their unblinking eyes
A sheet of massing starlings
Like a crocheted parallellogram

Blue the moon gradates as the day
Awaits to creep into the scene
Starlings weave to pullaway
The orange sun climbs slowly

Up the black wet and enlightened
Trunks a silhouette of gathering trees
Walking off into infinity a million leaves
The birds diminutise to tiny fleas
A pigeon arches back and plucks its tail
Mourning traffic horns wail queue impatient

Congregation congregation congregation
And every one of us and every living thing
Impatient
Gets up and off
To search our holy grail...
In morning murmurations

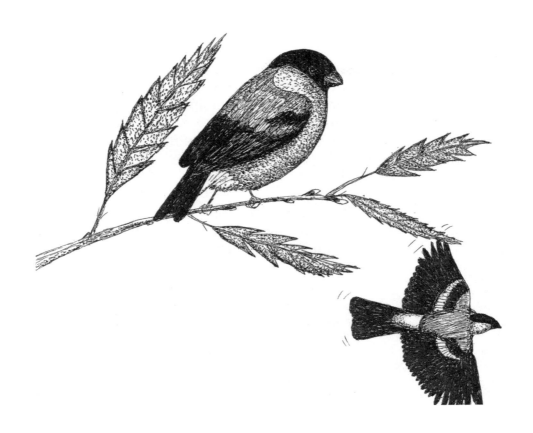

SOUP OTTER

To the brink swimming
In a sunk hole sinks
Below the Neowise comet shrinks
Jinks in the dim dawn time streak
A Soup Otter whitish yellow pink
Pulsing oarlike surface strokes
Trailing tresses coiled spokes
Golden chokes the winding
Stream of mind

Passing as she winks aware
The moon's a rind
That in her eye beside the molten stye
And floating there
Down where the Crookwood blinks
Gloating ... thinks a man ...
Who drinks ... links

The setting moonshine
Spreads like butter
Chinks in wavelets
Wick Lane gutter stutters
And gushes sprayin' as in
Confluence spake
From Nine hills springs
Grows Drews Pond lake

Flows the stream
By Drews Pond lane
Where stretched behind

Her golden mane
Snaps her chains and
All about and lapping slinks
A wallowing lithe beguiling
Diving laid out and divine
Smiling
Sphynx

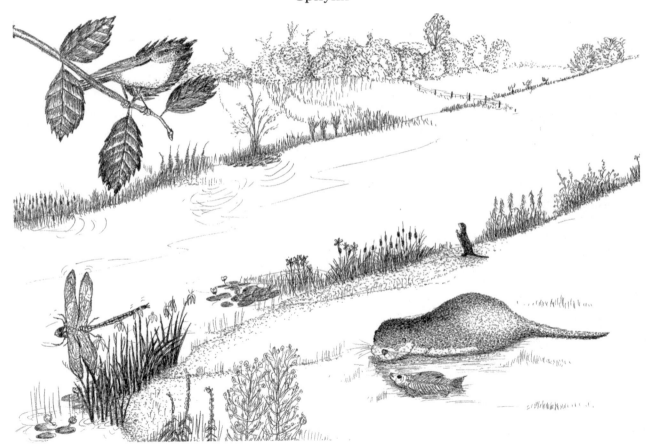

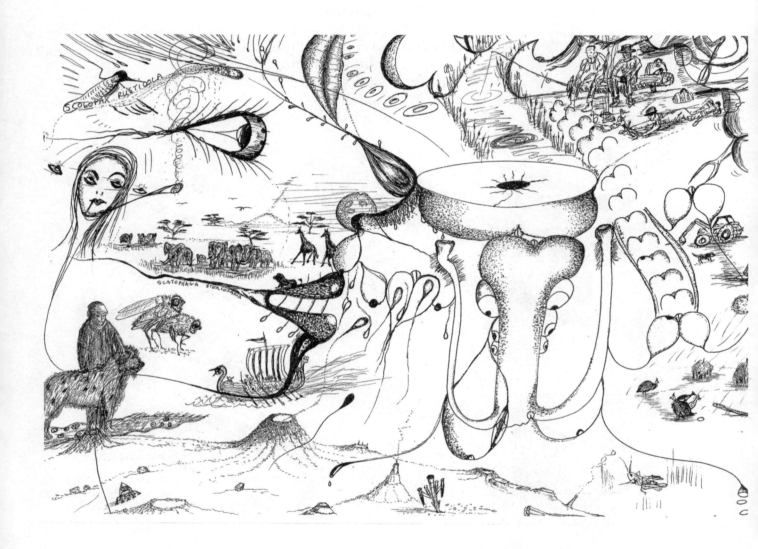

MY SONG

And it's so long now
Because for some time
You've bin in
My thoughts
And even though we may
Have lost the time
I still feel strong
Coz you were in my song...

It won't belong now
But for sometime
You were in my head
I remember
How you said to me
If I had heard
The words you
Had said

Beneath your breath
That I was in your song
But I never heard a word

And as I write my song
Now
Those words about you
Will belong there

But its so long now
And the spirit in my soul
Is slipping low
But you were in my song
I was in your song
We were in our song now

13

WINTER

All hunkered down
Now is the winter of our... not intended
No warming brew
Sat in a limbo discontented
Badger fox stoats weasels too
All stuck frozen
Down a frozen flue
Nested in strung brittle vines
Crisp spiders hide in rabbit holes
Nested in long lines of ivy slung
In little spines spun in a spinney
Where nettles blackened hung
Their sting neutered
All living succulents dead and lied out
To stay alive
Pigeons glide frosted wings
Ever decreasing circles plied

Compounded drifts of paper leaves
Thoughts bottle necked in short
Frozen springs choke backward to
Aquafers like rods of iron
Hard ... taught
Dun greyed beiged soot-dulled
Done
To a tinkling spinet strung
Chords of frozen strings
The scrambled fingers of malinger

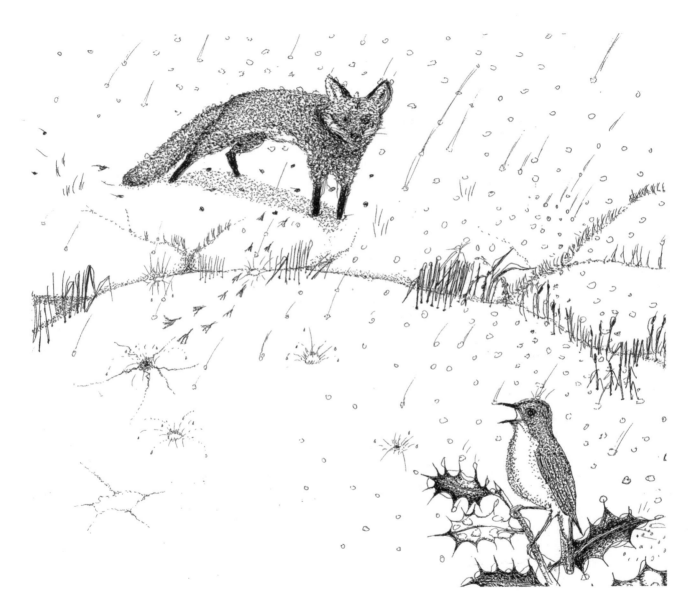

This milksop nestled
In breasts of alimony
Sings for a penny honey
On corroded cobbled roots
Spilling down into rotten
Steaming ravelled streets
Of grout

Eyes she wades through
Up to the knees in clay
Brown as nicotine
Blown the smoke away
Tobacco shag feathered plumed
Tails bunged up dead moss browned
Unfed mouths strapped shut
With rendering cold
Spat mouthfuls of polluted fume
In a crenulated tungsten tyre tread
Rolling round the sunken downs
Tined turf and mud upholstered
In its landscaped eiderdown

Weak sun devoid of light an heat
Thrown far off out of sight
Hide behind your wall of fright of peat
Grey nothingness of cloudy thought
And quiet ... quite forgotten
Nights

TRUCKLES OF CHEESE

We'll get enough sleep when we're dead
With that alibi in mind ...
There is a tent
Beneath its canopy I creep
Secretly erected in my mind it grows
I watch your eyes as they sleep
On my dream
It is not a nightmare at all
Glowing two truckles
Cheeses like moons
Silent ... rise and fall
White orbs
Yours ensure proportion to your limbs
Therein sin censures
You rear
The total antithesis of a pall

Bold 'cross the field you strode
A field which is your own
Retrieving stranded blown
Golden tresses
Which tousled undertones afloat
Of breeze playing like a tissued
Comb blown on the collar
Of your waxed coat
Up your sleeve under your chin
Below that fine sculpted nose
A nearby warbler echoed
Awoke in me I rose

And wove woodbine around into your loins
And out as you walked out about
Shepherding your dogs excited for a jaunt
As was I aroused
My thoughts in fogs
Swirling about your silken thighs
Obscured as I pulled you up
To my shamed face

The tune erotic wound
Melted in the charge
Static heat around your soft self
Your hands which then pulled my head to you
Your neck then missed your grasp fell
Which arched you back
I caught
And that soft mouth
I nearly kissed a few times now ...

Must endeavour to meet at last
Before much time has past
Before the long moment has lapsed
Or my chance disappearing fast then...
Casting away forever my line along that
The inexorably gentle rolling stream
Running water creasing at my helm
Races run riddles over pebbles
Merely memory

And off out drowning in sea
And as the tide recedes
Unclearly
Reflecting in a rock pool
Now only traces of you
And me

SWEET 'VIZES

Sweet 'Vizes sleeps under
Georgian rooves split to meet above
The medieval street
Whereunder lovers creep
Entwined where love finds them
Where once roamed drovered sheep

And freezing the shepherd
Blew on his frozen fingers
Watching out for thieves
Loiter and linger outside the castles keep ...
Now homeless folk light cigarettes
Rolled thick as teabags burst
To get them through the night
To get them through the worst

And as the trioed bells
Sullenly expel yesterday
A sonorous gloom invades
Transcending down
Of orange lamplights shine
And shade down further down
Floods the damp lanes
Twixt garden panel fades

The town melts out to countryside
Beyond beside and back up
The stranded locks and pounds
Of the old repaired canal
A working sculpture now
Kinetic Kennet sounds

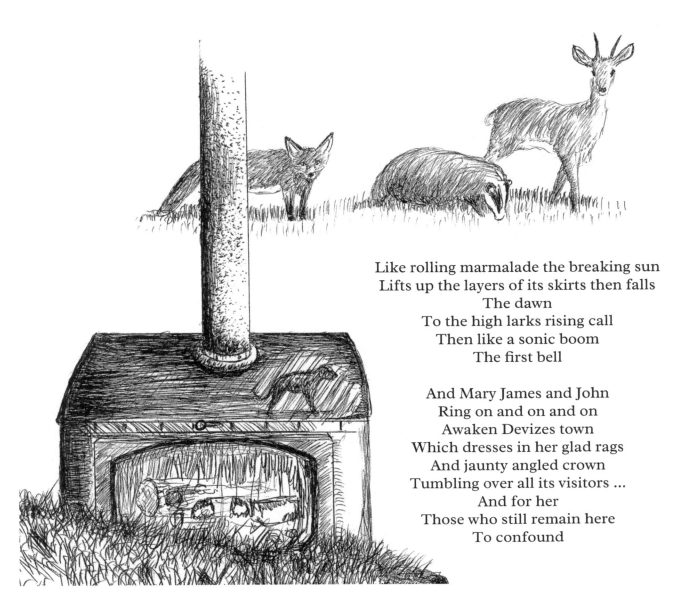

Like rolling marmalade the breaking sun
Lifts up the layers of its skirts then falls
The dawn
To the high larks rising call
Then like a sonic boom
The first bell

And Mary James and John
Ring on and on and on
Awaken Devizes town
Which dresses in her glad rags
And jaunty angled crown
Tumbling over all its visitors ...
And for her
Those who still remain here
To confound

THE DAIRY COW'S DEMISE

The cow lies wherever
A bed it makes
Bivouacked
In amongst the cakes it
Bakes

Off the farmer cries at his
Mistake
An' so he oughta for sending
Off his dairy herd to
Slaughter

Advised to diversify
If only pigs could fly
He didn't listen to his wife
When she said "Try
To make some cheese!"
They could've made a killing
At local festivities

They were his one and only
Brood and not with
Standing that
Not possessing any children
They were really
Where he's at and
His adopted daughters too

Of course now full of regrets
He says

He ponders on his life's
Investment with a farming
Way
And when he adds it up he frets
Can only pray for today
There's nothing left to do
For ...
This is all he gets

THE MERE

White seagulls over wield a
Mere drop of water in a field
Book opens ... pages
Flicked ... an purr
I sit up and read but their
Incongruous invasive screams ...
I lie back and day dream over...

Lain in buttercups and clover
But the sea is miles from here
Put out my hand and try to reach
Midnight creeping
Up a shell white beach bleaching
Moon a white out sheet

Crusted on the cottage rooves
Behind a sledge's sparkling grooves
The imprints of seahorse's hooves
Frozen in the blue white snow
From a million years ago

And still the waves beat on the shore
And still the sound for ever more
And still on the wind as well
In its slip stream I can tell
Upon the mighty ocean swell
A mighty Viking ship is racing
Bearing down on me and chasing
Weapons held aloft eyes tracing
Their scream all embracing

And the salty seaweed smell...
Awaking
And when I turn and look
It's me...I'm all alone
Crawling out a mighty book
That's resting still and on my knee
Up above still seagulls scream
And Crookwood brook
Below me steams
Beside a pond
Within a field

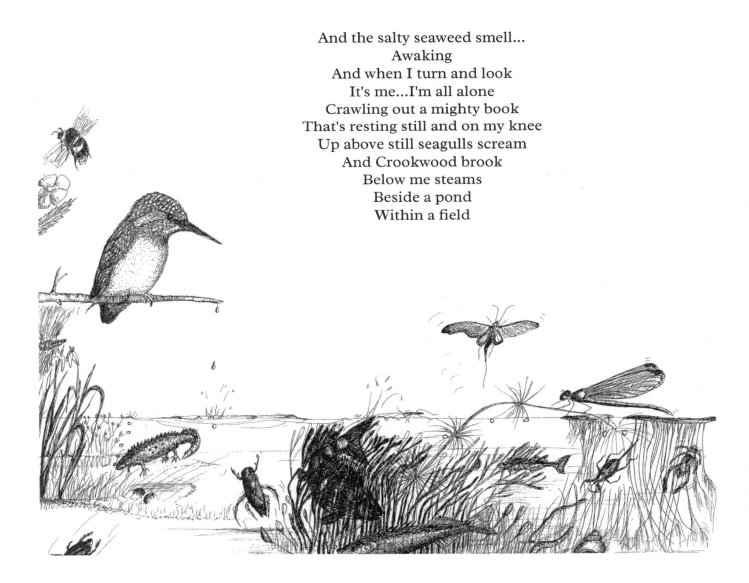

MOSES CONTINUED

Etched in stone then
Tattooed on my chest
Then the nail held in the fire
Went through my skin like butter
And though the mountain blew
Your words across the screes
And I with the tablets clutching
Did I there slide
Back down the mountainside
My Lord
Of course did I stutter
And falter
And when I built the rough hewn altar
Out of that same mountainside
The earth still quaking
Because my hands shaking
Your Grace...
For
Only I
Ever saw your face...

THE BABOO BOY

We lay back in the linhay
Shipping air too warm
Thew whinney of the old horse
By its creosote brote

We blew hard all night
My kidsey fast asleep
Wrapped up in a swaddling
Skin of a sheep
Thank god on the cushkens
Of moat
Which kept him afloat
He walks on his hand and feet

Linen
Haemorrhaged ribbon
From toe to throat lime green
"Let's just crash here and live
On gin!" You said
In a wonderful clover sheen

High there in the raftered messinet
Hung up in our hammock
Swung
Was it to you or to me
To whom we both long
To be to

And we were proud foot in the slung
Autumn
Grass tripping down in the hay
Wild yeast settling east
Proof
As it pastilled blinding
The croweye sloes

Forced down the bottle neck
Ideas an crystaline sweet
Where sugar solidified
In the crenulations
Of it's twisted teeth

Giggling like kids you just
Had to stick your tongue
So far in that it stuck out
You couldn't unstop it
To unblock it
When you cried in pain
Again and again
All bottled up and let out fane
But mostly 'cause it was all insane
That life so hard to be

But mad weather gripped tight
And then more fever bite
Flung headlong in song
Humbled we cobwebs strung
In the cold wind torn haycocks
From the east doubled up stalked
Upon our thumbs

Tiptoeing in the creeping frosts
To pee before the freeze
Staring out through the curtained window
Flakes landing on your nose
The icicles in the breeze
The hose too hard to squeeze

Rust creviced redoubted land
Leaves strewn on the altar cloth
The grit in those cloven toes
The landing of a moth
Sheep waddling in the cloisters
Gnawing on candle's
Wax
And all in the bleak each day of the week
Yet no one found our tracks

BÊTE NOIRE

A big black beast of a cow
Chewing the mow
Lifted up its nodding head
Somehow and espied
Its ide'e fixe
A delicious blend
The lush bed of pasture mix

Of opened orange rind
-Eyed tinged
Buttercups breached into
Long grass stretching bleached
Raised up and far ahead
At last in reach

It had a gentle reflecting
Moistened eye prone
In the middle of a black patch
Which gave it a piratical look
On closer scrutiny was found to be
A crawling mass of
Invasive flies
Which never left it alone ...

Their queueing cloud hovered above it
A humming shroud
As it plodded up the stert of land
Which drove into the pasture
Causing the steep rise at hand
It led to an oasis of shimmering
Butter

MARK WHELEHAN

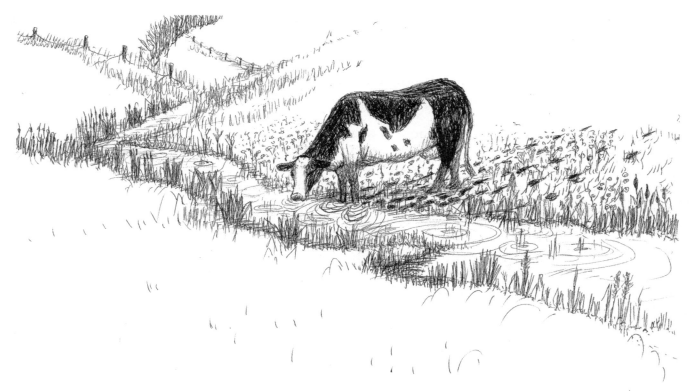

It's tail swept from side to side
And fought these rankling insects
A relentless mechanical rudder
Conducting their choir
Tried to keep its backside clear
And even reached up to its neck
To swat it swayed
But pitiful creature what a
Squat show of respect to it
From them was paid

It had need to enact a farcical
Facial screening with it's
Curling tongue and ears
Attending to here which was never
Going to clear their dour endeavours
The great black beast
Had little power
Over its bête noire

31

THE DRIP

Still the drumbeat of that
Dripping water on that bin
And there where the snail
Climbs up to absolute nothing

Where in detritus around
The sodden drooping yew
A broken egg shell
Now degrades sprang
A feathered messenger
Of sweet sounds
To you
I might have
Heard the tiny thing singing
Lying in my cocoon of a bed but
Listening awakened by that storm
Still dripping dripping in my head

And in the raving storm's crest
Storm cock raging
The slightest background
Noise
Dripping water on that bin

Now winds gone tailing off
And in it's wake
Yet that steady drum beat
For God's sake
That relentless drip

Stops me slipping
Into sleep
Summons up a spirit invoking
Something wailing weeping
Some clandestine thing
Hiding abiding in that bin

Yet nothing lasts the sky
Has now cried itself out
Sip sip the gulley dries
And with a sniff
For now just sighs as gradually
The drip dies

NO MAN LANDS

Blood shot the pheasant
Free falls
Into the morning call
Awakening sun
A stye within its eye

In no mans land
Mist hangs a wrist
Gripping time on the
Circumnavigation of
The morning watch

Far from the earth
The buzzard hovers
Battling cartilage wings
Snapping tight feathers
Fiercely holds
The calibre of the wind

It grabs a piece of a cloud
And punches at the air
Delivering a piecing cry
It too falls awry
Suddenly it must jam on its brakes

There on the feathered floor
By the pheasant rolls
The cartridge charge
The gun snaps shut
Like a door on the scene

Off strolls the keeper of the woods
The limp neck echoing his sway
The buzzard blinks
And in that blink thinks twice
Beats wings in time
As time flies it beats away

35

FRIDAY THE THIRTEENTH

When I pass over from the Green Lane
To the Potterne Woods I can imagine still
Where once a beautiful traveller-girl
Moored a pony and her old Gypsy caravan had
For a few weeks stood
She astonished me...
Stood tall and graceful with cultured deportment
Enchantingly passing the time of day
As she cooked her mushroomed assortment
A breakfast on an open fire
She stayed and whiled away some enigmatic time
In those summer days
When she spoke her voice resonated her disposition fine
She answered with pertinent
Questions to mine
The smell of honey suckle
As she suckled
Her newest born on a bounteous breast
And wood smoke blessed

The way she tucked long curls behind
Her perfect ear as she chuckled infectiously
I can still see it all and the sun how it
Set light to her hair and early
One summer's morning in a breath of fresh air
Coursing across from One Tree Hill
As it shone through her diaphanous long dress
Created her outline so feline yet debonair still
Her dress whipped up I gasped then it settled down
Clung to her curved completely naked form

Her eyes bore relentlessly ever deeper into mine
That frown just as captivating which grew when
I conceded hurriedly mumbling stumbling
"I'd better get on and off into town"
And the long tresses of her hair as she let loose
Her ribbon
Tumbling down

The empty vacuum when they'd moved on
Evidence of a nibbled hedge
Just a burnt circle on the ground
A missing edge it
Left the view mundane
Somewhat bereft of value
This landscape has without people

I glance over in that direction of the skyline
I trace along the treeline of oaks and beech
Each has an idiosyncratic shape
Like hands
Silhouetted against the horizon
A vivifying effect...my words honed
Crop up and brighten and
Surround this tale with a halo

I look down from my Land Rover cab at my hound
Running along with me at a graceful pace
Eating up the ground
His face so grey and pale with dark haunting eyes
Who looks so sad even when he smiles...the guile...
But the song is sung

My dormant memory tightens and defined
I could not make it up
A story sadder now than it was
Then ... on reflection ...

I had seen his face somewhere
A face ... I don't easily forget ...
A name often with regret
The sky fell in and the rain came on ...
The old leaves are falling
But yes
The song is sung
Yet
The wood keeps calling me back again
Blackened wet the trunks and branches hung
The copper gold and platinum leaves dappling
The floor with filtered rays of sunlight sprung
Spokes revolved like cartwheels through the greenwood
We shook our heads and walked off
Me Stuart and my hound
With his sad ghostly look
That said it all
The Irish Wolfdane Crook

On the left we had earlier taken a spur
A sunken lane and down into the woods
We saw the tent where he must've stood
And reflected
Some fellow homeless I suppose some mishap

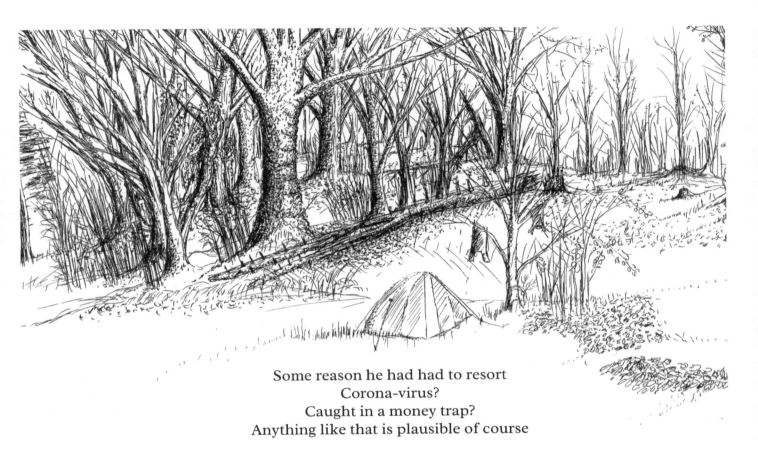

Some reason he had had to resort
Corona-virus?
Caught in a money trap?
Anything like that is plausible of course

Wonderful winter fuel
And all the woods to pitch a tent
God acts arbitrarily with a slap
If we wayward bent
We choose our own efficacious way
There a pigeon burst the silence
Woke the spirits which
Brood there
Woke them with a clap

Those ranks of trees
Some injured dying falling
Like an army standing down at muster
Twixt the pigeons haunting calling
Flanks of an ageing regiment you feel them
In the shadows in between dusk's fading lustre
So hard to see through
Only the gentlest of breezes
Allowed to play teasing the frozen movement

Stuart held my Irish Wolfdane Crook back
Allowed a family on a walk about to pass
I had parked in a way forced
Them to huddle before a giant puddle
We bid them good day
Then we turned
And viewed the sad deserted scene alas
Where suspended in animation his camp
Had been built ... and to see what had come to pass
Crook hunted scents
While our eyes searched for odd clues
Some T shirts hanging there
In an elder sapling
Where furtively perhaps he stole into his lair

Here too nearby a sunken well
I'd happened on many years ago whence...
And an old midden ... by the perimeter stile n fence
I'd tumbled down the slide of a hollow
Where if the path you followed came upon

40

An old tumbled down gamekeeper's cottage
Ironically had mellowed under knottage
Briared and nettled over
Some fruit bushes the only hint of use ...

Short times he had here he
Must've heard pheasants make their throttling call
When they wake at dawn
Oh to be born again his night times spent
Inhaling stars his fire its smoke winding stray
And entering up into the milky way
His thoughts ricocheting about among
The cosmos up above
Wondering at the polar wending fundament

Some home he'd chosen all alone
Where badgers deer and foxes roam
A thin cloth between him
And all the world to see
And the closing evening light
When eyes play tricks
Emotion can lick sour thought
Into a sore which scores
What shade his mental scars?
Maybe he'd just given up on life
Anyway he was dead apparently
Enough said
No more ...

Makes you think though
An empty tent his bed

And clothes and a few possessions kept
Hung out to dry in a nearby tree
Could've been any one of us mother's sons
Could've bin Stuart
Could've bin you
Could've bin me!
And then when we'd sorted all that out ...
Let's go chase a dream young man...
And all the world to be

Witnessing those pale silver streaks
Of growing dawn
Inhaling geosmin while yawning
That irregular sesquiterpene
The smell of the wet fermenting earth
The smell of rain
Gas cooker for his hearth
Did he appreciate the development of form?
Growing brighter as too
The vocalizing of morning birds
The lowing from the vale
Of Gordon and Nicky's rousing cattle herd

The mercury beads of dew
Rolling off his tent in first glow
And his hands pink and blue
Sniffing in that cold air that makes you cough
He must've beat himself about
In order to get warm ...
Leaves rolled settled like discarded
Litter in an urban street
Hazel ash horse and chestnut sweet

Lemon reds rusty duns white and limes
A disco floor of coloured light
You felt you could've danced upon
At a more appropriate time

There is a silence there
In that remote dingle
An atmosphere almost to prelate mystery
Where hairs tingle
A clearing in a wood
Mist filled a foot or so above the floor swirled
About one's feet dispersed
A hand put out to feel
Creates a state
As in a dream it seemed
Not to be real
Crook my hound lay back an ear
As the only sound made
Was a twisting broken oak limb
Creaking like an opening gate

We went about and so left
The place to the woodland folk
The pigeons sad cooing would invoke
Continued up the soft
Leaf moulded sunken lane
Then off back along the muddy track
As ancient drovers could
To Devizes market
Through Potterne Wood

43

As a wind picked up a minor chord
I could imagine a distant call echoing
My thoughts bereft of his identity
"What's his name!?" "What's his name!?"
I turned to Stu and asked the same
He shrugged his shoulders
No one knew ...

Rumour had it
He or someone matching his form
Was found drowned
In Braford On Avon canal ...
A week before
What sweet voice of trickery
What siren lured him
Onto the rocks ... there but
For the grace of God
Go we

We ploughed on with our day
Less bold than profound

Me Stuart Brown and my Irish Wolfdane Crook
All heads down marching forth ...
We hardly exchanged a sound

TOMORROW

Just before I went to bed
He looked up at me
As if he said
"I may not be here tomorrow
I could be somewhere else
Instead"

And in those eyes
Which I now see
In retrospect listless
Listed
A quarter of my adult life
And good times
Played out
As he existed

SANCTUARY WITH SIN

Inside a thought
The outside world bursts in
Gate crashed
Am at a loss
How to properly react
So with grace allow to sit
Sanctuary with sin

Unannounced
All lapis-like
The peacock with a
Sublime movement takes off
Alights upon the apex of the roof
Himself even more aloof
Adjacent to the weather vane

Turns a few times and round again
Faces south west prevailing
How many times he looked
Off and into oncoming wind
I do not know
No tear I notice in
His black eyed pea
As a storms runs in
From the Severn Sea [estuary]
A double glazed lens
Deigns
And somewhere in that eye
I see my full reflection
Looking back at me
And my

He shows no pain
Exotic crest like a
Cushion of pins
Spike
A graceful pole
Me an Ma
Exclamation mark atop
An irridescent glow
Adds to the startling nature
Of the cabin nestled there
All Burmese teak
By the burnt out oaks
All closing ranks
Below

And as the shy sun pokes
It's nose out from in between
Some rude obscuring cloud
Unmoved it sucks no thanks
My proud sin rushes out into
The wet suffocated winter
Prancing
Like a rutting buck

So what the fuck
Says I ... maybe
Five ten fifteen twenty
Years now before I die
I've given up
So I give in...

46

Then I give out
To what?
Too late to regret at least
I know now
What I am about

NAKED WE RUN

Then there you were
Burning by my gate
Exploding ...me
Apprehensive pensive
Instead...
We have had intimate
You said...

Never seen you'n such a state
Your muddled moddled head
Looking up from the table
Pleading for a bottle of wine
An'a bit of cheese
On a piece of bread buttered
Uttered...
Mark can you just
Do me a favour
And let me in
This time

Those teeth lipped parted
The smile shone
The dress tore off
Then the thong
A piratical picaroon dipped
Marathon
Where fish were shipped
Flashed and shine
In a mackerel sky
Where a memory formed
In a mind's humdrum eye

In and out the shallows
You prevailed
In and out the caverns
Of marooned doldrums
Small conquests won
And failed
You sailed

And in that splash
Of naked sunlight
Rods of chrome
Come and go
Steady up materialise
Grow into two
People shaking hysterical
With the cold

Like on an old projecter
Shown memories
Opening a camera shutter
Clicks slowly fading light
Slick licked and tight
My eye roams snaps shut
Take one at the shed
Surrounded
By my friends
My animals
My home
Stead

...you and me
With nothing on
Our white reflecting
Limbs
Sparks of bright there
Against the duns
And shadowed dims
To share the air
You lured me out
With no clothes
On
And as we spun
The noises hummed

Splashin' in that hose
Squirted indiscriminately
Innocently one
Getting worse crueller
Then perverse
One knows but carried on
Your laughter louder
Caught me in the moment
Spun your blood red mouth
Teased open
By your flashing tongue

Stuttering machine gun
Opening shouting crying
Laughing pouting
"This should be tried and done
Once at least in their lives
By everyone!"

You're mad I splutter'd
Guttered in the flame of water
"Those opposed should
Be shot with the hose!"
You dribbled sat
Down on the towel
Blowing bubbles
Out your nose

That dried cleft
Your shy sham
Poked your tungsten
Tongue stem
A rude pink intrusive
Flapping prehensile spam
You twirled your hair
Around your right ear
Which sticks out further
Than your left

An armed Venus- in
Conjunction with Mars
Tresses tied up like
A lithe sunbathed lizard
One reclining on a Greek vase
The green chlorophyl of the
Translucent leaves on trees
Dappled your arse
Acting like a screen of modesty
Smiling arched eyebrow
Performing
Pleased

Summer subsided like
A plug pulled out
An overflowing sink but...
Your gurgling laughter sent
Echoing down an autumn pipe
To freeze like baby mice... nude an' pink
As a winter memory
In a choking orifice
I sit and think

As a silver trophy spinning
Carried high thrown sentiment
And far from any maddening
Snowball throwing crowd
A frozen shroud
Hung over the old canal
Thrown spun and tinkling
Blades rush
To a standstill
On the heavy crust of ice

Back in that orchard eden
The sun through blinking
Fruit studded jewels
All quiet all still till you peed
Out loud
Enjoying my discomfort
Peels of laugher
Coming forth

Out now you ruled
In my reticense to confront

And in that welded
Mask I felt
I wore I reeled
Turning dizzy
You set my mind free
Time has realised it

T'was no mask
Just an expression
Of an episode
No more no less
As valid bore
Our many characters
We each employ
Sometimes miss
Sometimes score

Looking up always up
Squinting at the sun
And alone just you and me
And since then
Often stretched
Like chewing gum

But snapping back togerther
Sort of chorded swung
To one another
Applauding...
Awarded to the fun
Not scared of
Each other now ...
Naked we run...

A PERFECT SPECIMEN GRAYLING
AN' A TWO POUND TROUT

And suddenly I wake up
I'm sitting at dawn on the bank
Gratefully
And thanking God
That I wake up at all and ...
Yawning like a seal
Wiping the late frost
From off of my sleeve
I feel the rod receive a yank ...

As if you accidentally clutch or touch
An electric fence
Keeping game within a field
The thought appeals
Escapes ... the shocks the same

And all the fishermen
In between me and F.M. Halford
Are irrelevant they are unseen
Yet they all have been
What I am now
And somehow that's what it all means ...
Rastrophiliopustrocity
And a touch of the old
Cacoethes prognosis

A windborn ribbon differing
From that liquid gold winding
Away at my feet reflecting a
Waking sun so pure as it does

Reflects me so perfectly
Is in fact a hovering
Population of airborn
Lure
Steam rising from the reeve
The lighted match
Struck up bright and loud
Smashed sparks

To deceive
In my dull head like a fix
An made me shout
As shot up from the river bed
A gleaming mercurial silver golden ...
Platinum mix
A perfect specimen ... Grayling an a
Two pound Trout

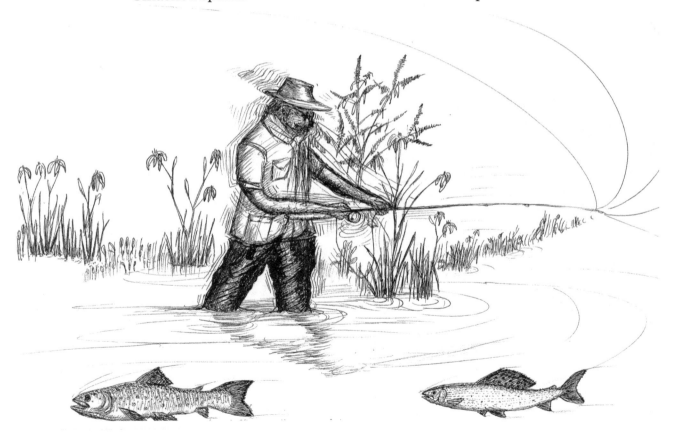

My hole ...whole
Emptied soul inside shouts
So loud and jumps about
God help me calm my self
I doff my cap and scratch
My ever-thinning thatch

Remembering fondly
Those wise old words
My father bless his soul now dead
Read and doled out
Passed on down the line ... to me ...
Match the hatch!

And then in a preposterous dream
The line runs out in a scream
I match it in an inner theme
In a gentle sweep I land this
'Lady of the stream'
Aquiver by the river
Next 'Princess of the water'
In reverence I awe to
As if I'm in a war too
I kneel and yes I ought to
Return them to the water

Snatch the air
Deo gratias
Grasp the day
Carpe diem echoes
Our chanted requiem ...
Jerusalem

THOUGHTS HAVE A MIND OF THEIR OWN

Don'tcha go in the winter
Go when it's warm in spring
I've fought against every
Flipping thing
And
Still now

There in thick flakes of thisk falling
Snow
That hand melted
Blurred
Into the ice

I saw the sun
Burst like a bag of rice
Blister purple red through a
Blue greyness once twice
Thrice ... instead
I could've bin dead back then
They said again
But my world my mind ... has
A mind of its own
I didn't recognise that then

REBECCA

All the long long day
I'm holed up
Sheltered in this
Cool layby where
Sweet smells of soft
Washed cotton stay
Which recently swished by me

And in the comfort of the
Cavern gloom
Reaches my nose and
Tongue the taste and scent
Of her rose in bloom

She shoots by
In her blue saloon
Wiping tears into a lagoon
That's forming on her lap
Tears falling like
A weeping willow sap

Her woollen hat she hides behind
Withdrawn within pulled down
Over her greying locks
How many yells she sells
To the uncaring chorus
How many denials she's made
To try to control
Of those crowing cocks

She turns the steering wheel
Elbowing her dreams
She pulls up sharply
On a thought
Then off with tyre screams

And where the swift
Skimmed graceful scimitars
Over the duckpond go
She ups and like a statue
Treads climbing to her home
Back up that dusty track
In the disappearing gloaming
Alone the night now
Black as sloe

THE POPPINJAY OF FOLLY WOOD

Beneath the glass ceiling ...

Turquoise grew like a
Pubescent beard misty blue-green
On the oak it clung to in frosted verdigris
Along its sturdy crinkled boughs
And cynical stern knitted brows
Where many years seen
Had flown ... a few more wouldn't hurt

A rotten leaf stew emanating from the woods
And vale added a pungent air filled fairy tail
With Christmas fumes did skirt the riparian banks
And streams and brooks round
Edges of ancient coppice woods
Flung in the mix a box of tricks
Gleamed ideas hung above brooks bubbling
Fast running broth of autumn tartan cloth
Rolled remnants of hazel oak an ash
Hawthorn blackthorn dogwood field maples
Vegetation of every denomination
In a great weaved mash
Of dragged molten leaves behind it

Hovering dragonflies hunted giant emperors
Translucent ephemera caught paradoxically
In ambivalent ice-cold sunrays
An old sheep and cattledrove now still
An artery of dog walkers' bucolic bliss
Biodegrading plop and pee

All whisked into the mix
As butterflies and moths fine inter-twined
With twisting honey bees and
Boaconstricting ivy suffocating mammoth trees
An withering looks in minus degrees from withering
Columbines nettles blackened and
Their stings dulled

Geese southward flew
In wandering wavering Vs
Like organic car horns high up in the clear
An distant aquamarine sky
Over lofty bachelor pines where
Crowded in their head popped up above
The oak and beech canopies
To lookout where below in their lower
Branches mistle toed very little grows

On their silent needled floor dug badger's loos
The prowling fox can't ask for more
For has his eye on the cock pheasant too
When it steps out of line
For now his sharp canine teeth clicked shut
Kept in their sheath
Tight beside his red tied tongue

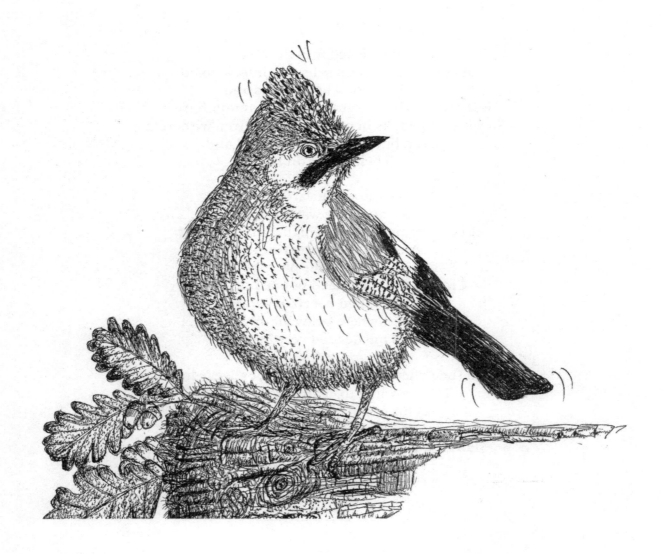

Windingwoodsmokewove
Through the patterned fields ... pastures
Where stories told of old and new revealed
The lives of folk he knew
This poppinjay

Sunken lanes he flew through high
Cliffs of greensand shelves
Constantly subsiding cut
Releasing tumbling roots Tolkienesque
Climbed the spirits of spalpeen imps an elves

This was the weft and weave
Entwined with so many lives
Threaded through sounds and smells
Crocus snowdrops daffodils
Caught hibernate in dingly dells
Bulbs gentle throb of life
In their cryogenic sleep
All which constitutes the potential
Canvass hues painted for the
Veritable acorn thief then
Of his bucolic fiefdom

Glide borne seeds
Never left to last
Picked up by the winds of time
Glyndebourne solos sung
Memories from the past
Lait por le corps
Jus sur la vende
Parachuting Sycamore

There she blows the train
Toots and comes and goes
And with its diminished tail
Deep inside a tunnel dove

"It would be a thing for me
To whisper in a hors's ear
Charlotte if you only knew
It's always a pleasure too to hear
To see the world anew
Through someone else's
Eyes you know that mare so bold
Who won't be told you told me
You flew across the downs
Riding as it frowns"

In the chorus of raucous rooks
The poppinjay sang this song
But he quite mistook
His own reflection in a puddle
For a more important effervescent fizz
From which an almighty struggle
An interloping buzzard
A'mobbing by a host of birds
With angels in a tizz a' huddled
Flew in and out of muddled air
In the Folly Woods just over there

In his own book he played the part
Of an expert in the martial arts
And in his excursion abroad an anti hero
From sophisticated parts

His false modesty was astounding yet to him
He was well grounded
How he was convinced that
While others winced
He drove the female of his species wild to want
Him and to want him madly
An enigma he thought himself ... totally unaware sadly
No one else there shared this opinion of himself ... nor
Considered him particularly different interesting or rare
And in reality felt he'd bin left
Upon the shelf
A piece of age stained cracked delph

Yet his crest rose and his tail flicked he bobbed
Up and down the drovers lane
It was natural to him being vain...

In an effusive moment
His voice rasped
But no one gasped
His voice was deadened
Drowned his own inner words unheard ...
Those relentless sounding
Gregarious birds
Understandably aroused
Now successful in their terms
Respectfully turned their backs and landed
Ignored him alighted
Quartering the field
Foragin' worms

And then on top of that
Up crept
The black tom farm cat
Rubbed its arse and curled its tail

A long lingering wail of alarm
Shot such a horrible jet of
Bejaysus at the feet of our little
Sweet Jaysus
Without a by your leave or indeed
A polite excuse ... all over the roots and
The tree inwhich he at present did roost ...
He realised something was
Remis amiss and seriously
Afoot
Resembling piss

The nostrils in his beak inflated ... aloof
His eyes arched to their imaginary roof
"I'll have you know young man
I'm deflated ... me
I would prefer you to urinate elsewhere
You see!?
Does one think one can!?"
"Fuck awf!" cried the common cat
With little tact but very much elated
And that to all intents and puposes
Was that... too late
At least for the time being anyway
And indeed ... as a matter of act
To date

64

GALANTHOPHILE THE FIDDICH

A faint tune trickles
Out to the washed mountain brakes
The rain tipping down it
Plucked Boulavogue on mandolin
Rusty shakes a long time bin
And a raven dives
And spirals in
A stag struts out on the tan hill
At exactly the same rhyme an rhythm
A log falls out the molten hearth
And I kick it back in ... the logarithm
All with the same swing

Galanthophile the Fiddich picks a path up
Through a de-frosting snowdropped floor
So to forge uninterrupted reconnaissance
Across a sweep of precipitating moor
Munches as hot breath rises
From his nostrils predatory trailing
The rich rotting December crush
Provenderabiding
And from his sodden hide
Smoke fuses
To the east
The wind has turned

Heather shakes her close
Clipped tresses
And a weak sun bleeds
Marmalade

Between the swollen bag-like lids of
A mucous sky
An eye squeezed back again
Tight shut

A thousand droplets tinkle
And sprinkle in the air
For out he trots erect
High lifting hooves
Carrying his mounted armour
Proud above his roof clatter
A splendid oh so lethal
Set of thorns

Suddenly he thinks he hears
The bell like bay of hounds
And the distant lilting horns...
He lifts his head synchronised
I suppose....yawns
With his twitching sifting snorting
Black leather nose

66

He could have sworn ...
And a spring of alacrity off across the plain
Punching out great clods
And clouds of exploding spagnum
Which mingle
With the softest rain

South-westerly prevailing
Blows on past and allows
The frozen forage lands
A chance to last -sailing
Out to a rolling sea the grasses
Whistle with glee in blasts

He lifts his head and all
Those thunderous emotions quiver
Suspended in an animation
Only a tear moves trickles down
His single shiver

Stands stock still ears like radar
Stops
Delivered ... safely
The music has rolled on past
A spoke of sunlight demands
A tear cast lands at last
On an opening
Display of ...
Snowdrops

BARKING

They tell me I am mad ... I
Listen
To the
Surfing sounds
Glad my sandals slide
On greensand on yellow
Grasses or on
Snow
Slipping like a shadow
Passes in and out cold
The shaded dusty glow

Other times when roaming
In a park with nothing to do
I'll stare cross-eyed at a dog
When the owner looks away
To make it bark

And in a while the darkening
Days will come
When feet and sand turn clay
And green the grass returns
In rain
Snow melts away
And all the world eventually
Will mould and rust into decay

But I shall not be sad
Luckily I am mad...
Or so they say
And dry times like snow
Will come again and sand
And dogs' barks will echo
Through the land

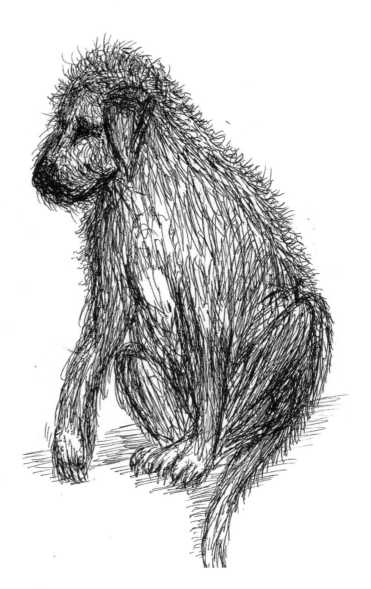

A CHANCE MEETING WITH W.B.

There is a spirit in this wood
Whom arrived quite quietly
But recently speaks to me yet
Infrequently stands alone
I leave him to his muse
This the decent thing
To do ... but

He may choose differently
Maybe I should call him in
And have a longer chat with him?
Although polite interrogation
Might not be his band

And my intentions might
Find him slim yet
I'd love to know where he
Comes from
And also where he's bin?
I feel

He lately seems the guardian
Of this womb inside
The coppice place
Where cocooned I am by
Choice marooned

Stood nearby
The spectred memory
Of her shimmering image

70

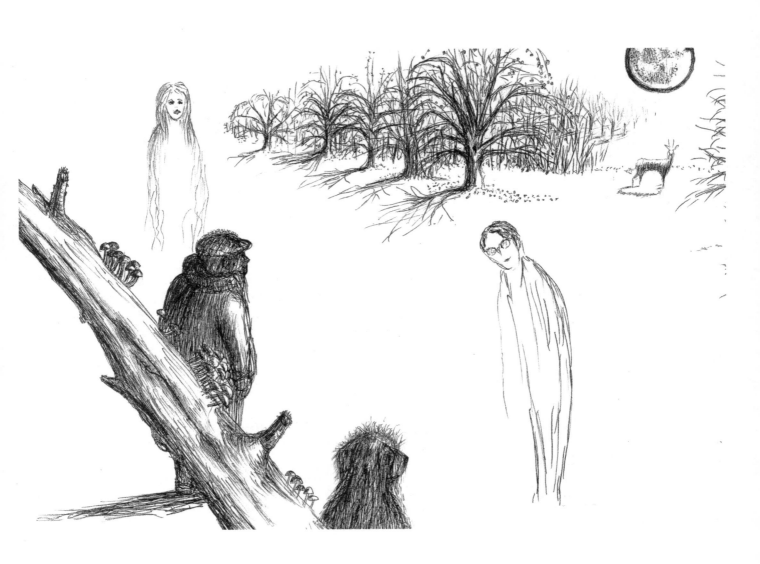

71

Stays
For searching ever for a
Lovely face I once chanced on
Who haunted me but ran
Had travelled far to find till
I gave up and settled near

But what's the word with him?
Has he been exiled here
For causing stir elsewhere?
My wolfdane growls then
Barks sometimes in darks
When shadows darker flee

I look again to check but
Nothing seems to be
There takes on the form
Presently of a shy roe deer
Who's often out there when
The throbbing moon full
I hear him crush
On frozen grass and
Crunch on iced apples
Left him in the fall

And in the summer's sun
Rush winds away sway
Appled shades down by the
Fence just by a broken stile
Where he steals in
I find in the lush
Spent apple cores
The codicil of a will
Bequeathed to one and all

Some time ... one time I'll call
Him in and reconcile and fix
The world and pass
The time of day with him
And chew the fat through the
Latter junctures of the night
Out in the moonlight
In the hazel coppice
Where lies the secret orchard
Where our silhouettes have spun
On on
Until the rising of the sun

THERE WAS A YOUNG MAN FROM DEVIZES

There was a young man from Devizes
Had tablets of different sizes
Went up Roundway hill
With a drink and his pills had
Imagined a world
From his window sill

Like Moses I suppose
With commandments to will

The strawberry pill dropped
A sunset popped ...
A metaphor flickered inside the crops
Roundway Hill overspilled
As the sky slipped around
Daunt seas became upside down

Across the sky and out for miles
A pulsing beacon smiled so sweet
Climbing up through bloody ditches
Over stiles ruddy stitches midges
Blissfully unaware there were man high
Nettles there

Looking back down on the brewery town
The greatest piles for miles and miles and ...
'cross distant fields below dissolved
The colours ebbed and flowed revolved
Shot out
And sprang back in

73

Wiggins and Duff and a distant me
Over there somewhere having a puff
Unseen
Behind a bluff experiencing
The said same amazing stuff

Paul Andy and I
Stared up at the sky
Asking our minds
For a sign of the times
For the meaning of it all
One thing we discovered
You have to go off and explore
To make it worthwhile
Coming back once more

No regrets

Sunset

Moses came down from the hill
God shouted
"Heyman!
Where you at!?
Stan' still
Chill!
You didn't have to take those pills
You can see all'a dis from yar windowsill?...

Now he tells me...

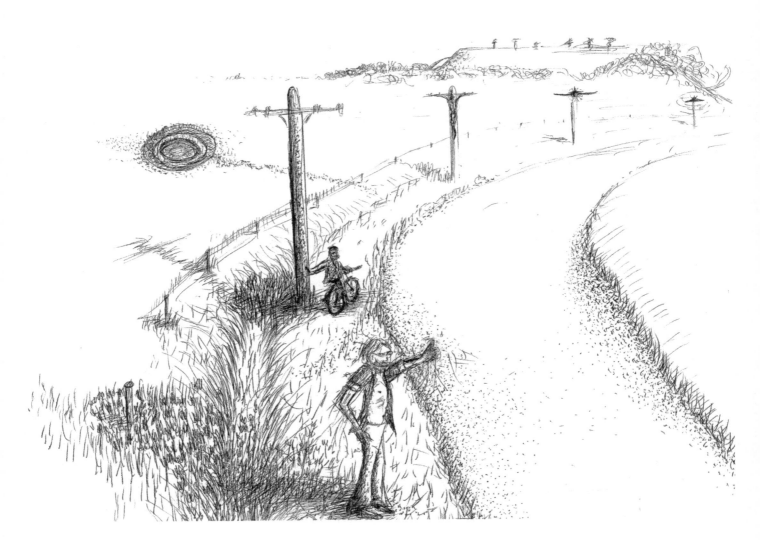

Monday loaded
Kaleidoscope exploded
Sunsets now and
Forever

And as I awoke and
Climbed out of a nettled ditch
I put my thumb out
Tried a hitch
I asked an old man cycling by
What day it was and in a fright
He cried "Hard to say!?"
He lifted his cap his hair fell off
And his head fell away
Just his mouth seemingly stayed
Mouthing "Some day!"
Oh Sunday!

I must have looked a dreadful sight
I stumbled on and heard him add
"Hold on young man things aren't that bad
Think it out and don't despair
You've been through that
And your still there!"

What a sight I musta made
Leaping up from out the shade
I must to him have seemed half mad
Covered in nettles and semi-clad
And swarms of flies around my head

Whisps of straw stuck in my hair
Eyes wild and darting everywhere
He looked as if he'd seen a ghost
Holding on to a telegraph post
I understand more now you see
Which creates such an irony
He seemed to me quite old yet
I'm the same age now ...
I'm told

So there was a young man from Devizes
Swallowed pills of two different sizes
One strawberry pink which helped him to think
While the other was yellow
Which made him quite mellow
And his dad was a shrink
Whatever d'you think ...
But it's all in a haze back in those days
And we hear the young bugger has mended his ways
As far as I know and from what I can tell now
I think that I heard he turned out
A nice fellow

THE SLOWEST FEET

In the furrowed field
Brown strokes brushed
Against green lush
The hedges flayed bush
Sewing flush seamed
On the text tiled fields
And the shimmering
Aquamarine

Evening blush
The sky dies on
My cheek
Pale my heart
Weak
My legs will not now
Do what they're told
I am dying slowly
Like the sunset
Truth behold

For us old men its early to bed
There's a long hard journey ahead
Truth be told
I take this in
Drink too long on
Too long I ponder on
For one with purpose

For us old men it's too early
Not for
The rising of our seeds...but
Our old hounds grumble
Turn about on their sacks
Once more to ground ... and
Our old chargers blow

Though
Still chewing provender ears erect
As herbivores are prone to do for
Alien sound
Reluctant champers at their bit
Our brandished swords an' shields
Once glittering on their battlefields
Long withdrawn impotent
Fighting of and for the young now
Supercedes

Six miles long the stream
Stretches strong ...along
Out like a dream
As stars come out cold
Red giants stalking bold
Descend on
The dead
Shrouded in steam

More impartial these days
These old martials of war
Crippled on the frozen plain
Less partisan upon
The bloody stain
Across the purple slain
The frost stops the blood flow
The only enswell to staunch
No yarrow out here to cauterize
That fatal sore

Severe
Lonely
Blurred more and more
Slow motion images
The fallen falling for … what?
The gain…
Pride? … baloney!
That voracious appetite has died

Alert the fleet hail those
Young blades to slow
Do they still not know
The journey's course and speed is
Dictated by the slowest feet…

At least we've made our peace
Before we meet

WAIT ...

There were ...
Now ...
Nothing there
And if there was
There isn't now
Too late

But still I fill
The vacant spot
Where once
There was a lot

And also
If you care to
Wait...
A little noise
Still emanates

'Tis the small voice
Left of noise
Where the soul
Was of laughing
Girls
And boys

FIVE TIMES
AND A NOD TO WILLIAM S

It is the morning
And it's early
Far from 'the hurly burly
done
And the battles lost and won'...

Now everything is easy
I watch the sunset lazily
In the hazy leigh
And I have the time to sleep
The stream is flowing smoothly
No monsters in the deep
Nothing seems to worry
My flock sound in their keep
My wolfdane alert lies like a sphynx
His calm sad almond eyes
Unblinking
Watch over me

No spurious sounds
Upset my hound
Under the tunnelled leat
Near the roadside fleet run
The milk churned waters spray
Spun midges where thrive a
Pair of grey wagtails like
Aqua pixies play clandestine
Dip n' dive from mossed stones
Flit up dissolve as ribbons
Into the brightening day

81

Above water crescendos
Become alive their hives
Rewax-amended at the seams
Where the stream bends
The waking bees
Play symphonies

Dawn lit mirrors shine
Clover filled with golden dew
Sates voles where scamper
Other wild fur bound souls
Sleepy deer start
As wheezy foxes whine lonely
And across some long tree lines
A distant crumbling church
Chimes
Five more times

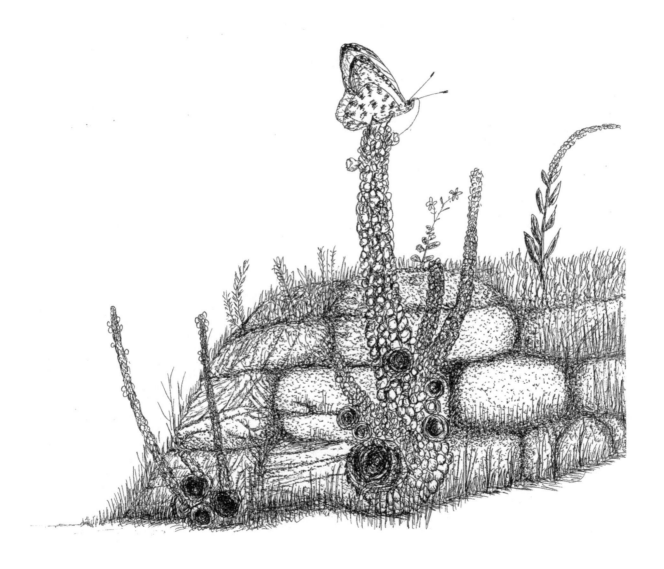

AWAY FROM THE HUMAN BEDLAM

I left the urbane chaos
Wearing a hood
Inside which a swarm of bees
Had built its hive
My mind withstood
But was almost near its wits end
And as I neared the wood

A water whispered there
As it races free
Undoes the lock gate
Which opens
An oasis of sanity

I seek this place ...
I take to it
The sanctuary of my quiet soul
Wherein travels this brook carries
The opened pages of my floating book
Which only sings a quiet song
A song which brings quiet things together
As it rolls along at even pace

And dark thoughts that chased me shook
Soon settle as time here wends slowly ...
I am allowed to think and awaken
And soon I am in sync
With the dying moments
Of the day shaking shrinks
The rippling cheese
Which floated in the stream

84

Metamorphosed into
A half-grown moon
Shimmered sparkling
Like a silver spoon
Dipped in a darkling ebbing light

A reflecting heaven turning pink
Now gone on to a shade of
Blackberry ink lapping to the brink
Stirred up festooned in water falls
With fainter stars and thoughts
Where clusters of those berries
Refract the diamond light
Caught
While in the mute background
A solitary tawny owl calls

Now the half-moon in the night
Washing away flashing splinters
In the dim shallows lit
The mirrored scales of a tiny bream
Glitter in a foggy steam
Crept across the scene
Wavelets straying rills gleaming
Weaves its way upstream

My love out of reach of it
In a merry go round
My head full of ups and downs
Those seizures of love
Which I ever took for granted
Now so profound are swallowed
Completely by a doubt

Create a frosted image of
A girl who from the negative spaces
In the coppiced saplings races
Through the dark recesses
Between the trees
In and out and disappears
Into thin air that freezes
Nothing stays the same for long
Everything seems to change
Years and life keep rolling on
Yet sweetly here
In leafmould scent it pleases

Moving not staying
Distant clouds melt in the young night
With wild night creatures' calls
In effervescence caught out
Purple sentinels dying in the turquoise
Twilight rushing in a breeze
Descending like a pall
Within without within without

A circling buzzard rounds
Like a sweeping scimitar sword
In a sudden blizzard slices
Mews in ever decreasing circles
In the thick snow now falling ices
Spues
It cuts and thrusts sparkling particles
Fall to earth like golden dusted
Ore

In awe
Ablaze a blade...like my cruel words
Did cutting through highlight
Soft innocent words of yours
Silencing my foolish fevered
Those irrational mumblings
Grumblings of a fumbling mind
Hung my head to hide
Saving my face from further
Disgrace...

I've found the lunar half
It glistens now on the
Wet rocks where run aground
My heart rendered after horrendous storms
Where sight lost I foundered perished
And where I lost my swing floundering
Unable to make a sound
A string snapped a heavy
Lead lost in your unfathomed depths

Drowned in mead taken on board
And in the sun set red flawed
My blood shot eyes
Strake across the bottom of the skies
Crying stopped my racing heart

A moistened wind alone
Sighs ...

MOSES' TYPOS AND THE THREE APOSTROPHES

Dear God
I want you to consider all I said in that sad face
Then retrace the words re read
Put yourself there in my place
If you don't mind ... if you'd be so kind ...
I didn't have the time money or space
The wind gushing out your opened head
As down a stream's course you race
Those three apostrophes your trace

I can't I can't I can't shouts a pallid face
Without those three grammar functions
Grace your read
Are the cries so valid space
A thousand letters in words retreat
Escaping colons on their dirty feet
Yet still they stand opened handed
Semi colon glanded

Commanded

And back they canter six legs standed
Those apostrophes are stranded
I beg you
Arms outstretched beside the brook
Amongst the vetch
The 'Moses in the basket' flowers
Startling rooks

And all the people write their books
Their own stories
FOR FUCKS SAKE
Ten Commandments?

Back along the cold old
Stoney road
The bleak houses fading
A shriek all told
Then another and another
Still I am old and dead instead
Floating down the brook embalmed
Caught in rushes becalmed still
The pungent leaves of cat mint
Lying on my closed eyes tint
Pages through a book flicked
Are blowing out a
Hint ... three apostrophes reprinted
On the window sill

THE COTTAGE ON THE DOWNS

A week ...
Weak
An occasional smile of sunlight
Broke ... bleak
Lips parted opening the clouds
Coming across the downs stole
Then gone a halo of mist
Warm breath caressed
Only after a gulp of scalding tea
To aid an acquiesce
No more or less a trickle
From the ironstoned stream in stress
Choked as it plots a watery scheme

Consumed rust red the brook bed silt
By eddies stirred and cloudy melt
Deep down the vale its throat
Ferocious squalls undressed
The trees leaf less
Stroked the sky with boney fingers
Broke a hole in clouds smoke grey
A spoke of gold shot across
The arm of a varnished chair glossed
In which I lay
And through the window screen I've seen now
A honey comb of old bees sleep walking
In the evening air say ...

Goodbye to all that

And from the dying heaven
... Aluminium everywhere melting through
Occasional white titanium then dark blue
Then black
Yellow and greens confined

To the photograph affixed
On the dull unundulating white wall creep
Reflections of the television news
doth mock
Its past six o'clock
The best the sky can do ... is sleep

Frozen to you
And all one can do is dream ...
And as a pulse ricochets ice
Age forms form out of the mists and steam
Stagger like ghosts across concrete plinths
And scratch their insect parasite ridden bitten
Flanks on follied obelisks
The grey chalk -walled frozen cliff of sea
Up over the shires and knocking ancient stones which
Remain in concentric circles like ancient scored lines
Underneath and round my old myopic unseeing eyes

Out of the freezing lists
A woolly mammoth appears missed
Irises on fire it sways an' whispers
Drags mudcaked feet snapping barbed wire
Up to the Alton Barnes white horse
Shakes itself and shudders in fear
And nods at its static equine neighbour
... I thought everyone
Died in France of course
I didn't expect it
Here
That horse

94

IRON MOTH TWO

As I drove down
Up the track in his foxy summer mac
Bounced the sorcerer pretending to be a humble stoat
Instant distrust crept my form
A dodgy profane monster in disguise
You can see it it in his menacing pin size eyes
When he jumps out of his anonymous coat
Shoots up your trouser leg
And pierces your engorged neck ...

Belted up he froze and avoided my intensive gaze
Almost toppled over pretending to be some statuesque plant swayed
His animation beat him in his fight off of electric movement won
He shot on past and failed to spot a peculiar moth
Landing decently on a rotten fallen branch
Which swayed every whichway
Its rebounding sojourn down the pretty stream
I smiled at the cheek of that martyr
And tipped my forelock to him the smarter ...
I left the scene

Laid on
Gravy sprayed on
Molten lead
Rusted fuselage
Of iron hammered head
Smote in a coat of creosote
Residue of cocoa tin
And all the shadows
And glints therein

Remnants of a rotten shed
Damp rot dry rot
Burnt nails and screws
Smouldering on a bonfire bed
A blown curtain frayed
Faded in the sun
Sump oil spills mushrooms
Flipped and fried as ghostly eyes
Spots about the wings tie dyed
Somewhere in all that
Patches on a mangey cat
Somewhere else
Poor wounded pheasant
Bled
Soon to die
His chestnut hairy head
The colour of your eyes ...
Spread wings
Faintly scalloped
Frilled

Eldest of my trees old alder
Death shook
Now floating balsa down the brook
It flew by in a flash of
Tarnished solder
Splashes of mahogany
Beige faggots haggis
On Hogmanay
A lighted mop
Alighted

96

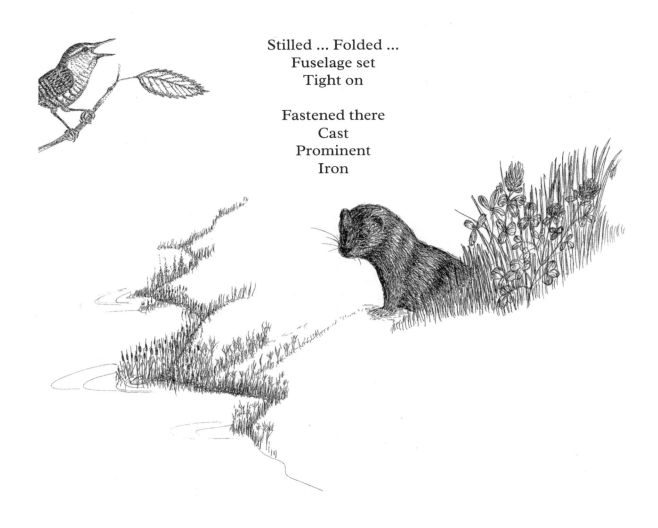

Stilled ... Folded ...
Fuselage set
Tight on

Fastened there
Cast
Prominent
Iron

WOODCOCK

Freshets caused by interminable rain
Boiled up through the fields again
Gurgling almost with a glee
Lifted like a dampened mist
The sombre mood from me

For from the sullen skies
Outta the very corner of my eye
There flew rare a surprise
A woodcock like a ferned
Camouflaged torpedo sped

The snipe like feature of his steady helm
Rested on the whirring bladed fuselage
Like a wood god speeding 'cross his realm
Some feathers from the bird lost
Blew up like a soft grenade

Only to evaporate into
Floating fluff
And there cast the bleary sun did quake
Behind its veils of precipitated vapour puff

Nothing could have shaken
Not stirred more around
Unless a bomb had hit the ground
Emitting not a sound
Ejecting nothing but confetti'd paper stuff
The grumbling wind given up could not catch
Left speechless in a huff

THE LAST PLACE I CHOSE

Glance across
As I look up
Slowly from a sleep
I am old now time's
Crept up on me
Still it creeps

Enervates my
Frame collapsed
My eye peeps
For familiar things
I'm not quite sure
A second or two
Till my cloudy mind's
Realised I am
Still here ...

Memory too my
Conscience stings
And on the bare
Unwritten sheet
On my lap
A neon glow
Of silence
Where I should
Have words
In flow
Though cheap but
Of worthy cause but
Nothing speaks
To me ...

Slower ...
My youthful steel replaced
By acceptance of the real
And though I still feel game
Enough faded frailer lies
The sterner stuff

I see many people walk across
That barren Salisbury Plain
Where for years nothing
Much has grown or gained
Or can ...

Then it dawns on me
The vegetation and
The people are the same
Mundane
Hu man

'Cept occasionally a rare
Orchid have I found
And in the gorse remain
And racing to horizons
The fast forbidden hare

And wondered at their beauty
Against unyielding wind and raw
Unforbidding rain which
Constitutes the prevailing
Unforgiving nature and
Climate of this bleak terrain

And all the years and years
Of tears I ever saw
I see it precipitate
In my poetic eye
Falling on deaf ears
From a disinterested sky

My oh my
There are few people
Of any note
Who having visited seem to
Pass this way again
And rest awhile though
Crowds still come
And crowds still go
And so I remain hopeful
Of another borrower of this space ...
Of tomorrow's child

For this is the first place
The birth place chosen
For me so meek an' mild
And the resting place I
Returned to for repose
Where I let my roots grow
I suppose
Into a man and back again

This is the last place I chose

WITHDRAW YOUR HAND

I slap my hand there
On the balding head
A smile appears on
The wear worn face
Forever this man has
Withstood the testicletwist
Of time teased
And never failed
And never rose to
A fit of pique
Whatever is thrown
Into his open space
However much maligned

And there with a rose
Between his teeth
We have such craic
Behind his back
Irrespective of whether
Or not we believe
He knows his place
He stands forever
Smiling back at mankind
Yet still
We call him stinky
To his face.
And all the disdain
We can muster
For fear of his disgrace

And all the teeth
That we can bare ...

Yet to his eternal credit
He is blissfully
Unaware!

REMOVE YOUR HAND

Unmediated directness
From ground to mouth
Nothing in between
From north to south
The iced apples fell

You're overdoing it a bit aren't you ...
It seems
With all that thinking!?
And what the cost of cause
Nothing lost or gained
All of us on a ball in space
Lasted as long as hot breath
Thaws a frosted window pane
The moon asmoulder on
Our shoulder bone
A yellow hammer washing
In a muddy puddle
The colour of yellow brimstone

Remove your hand young man
She is the mother of the brothers
The sister of the others
Remove your hand
The young tree must take
Its own stand
Leave the thing alone

The sapling must take its own chance
Like each mighty oak before and since
Withstands the sticks and stones
Which glance and scar its side
Whatever's thrown its way
It's prone
Through sun wind frost and rain
It must learn to stand alone
If it is to gain ...

Ecstasy and pain go hand in hand
You know that to be true
Else
How could your mother
Learn to leave you?
To let go of you?
Or conversely let go your hand
And learn to live with you?

DIS POND DENTED BURST

Across de pond
He waved his wand
For all de world to see
Amongst dis apparent confusion
Der is an element o'dis order
Dark an iffy flowed out the Liffey
Anny ways it can
So we tried another root
Dark'n dreary ducking an diving
She played upon the flute

On an' aboutta bleary sun
The mail boat Hibernia
Low slung ana'listun
Entered in an' eowt Dun Laoihaire
Both hernia weary
N'ere so black with the Guinness an' craic
The sky seemed it would break
Drunken seagulls spued up bile loike
Banshees in our wake

I heard the cry of a papist
A drown did by the wind
Shoutin' about somethin' to shout
About ... somethin' that he'd a'sinned

Off up in the shy shot Jesus Christ
On his nuclear crucifix
He couldn't care the least now
For all us thirsty ticks

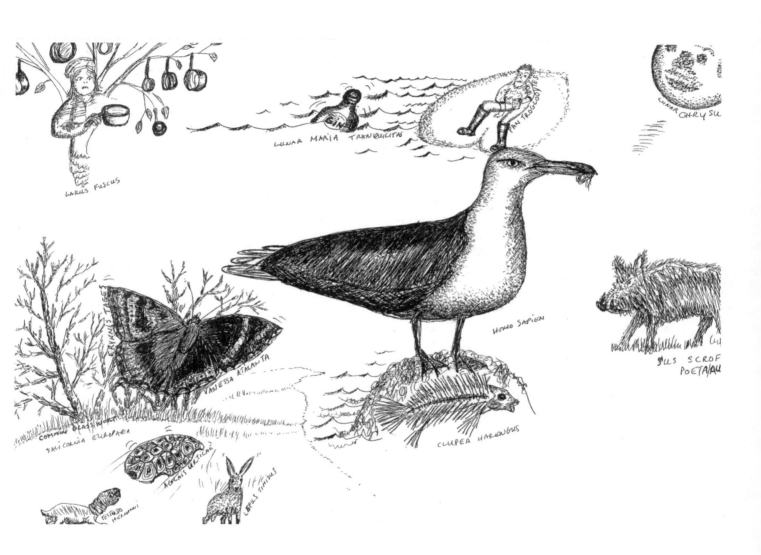

He'd made sure he'd filled his pockets
From the candle box collection
Our eyes shot from their sockets
All in the wrong direction
His boots tied to some rockets
Laughin' now as he sped away
Tryin' to hide his resurrection

We'd gotta
Goodrunforourmoneythough
So we had to see the joke
Burnin' blackthorn tough as iron
Too wet to burn and poke
Too thick to learn
Too daft to see
Fed on spuds an' poiti'n

Drinking porter black as peat
Walking muddy tarmac feet
A time we had a whaler
Absolving the congregation
With our mighty put shillelaghs

Wet an windy sings its song
Smacking our purple lips
Never warmin' to approbation inta
The Erin winter slips ...

CROOK'S DREAM

Crook sleeps
Crook leaps ...

The pimple on the moon
Deflection of a meteorite
Effervescence looms
A magic mist of a hematite
Spills and trills of birds
The swerve of pipistrelles
At night ... manoeuvre shell
Exploded
Booms!
Echoes down the wolfhound's
Avenue of standing stones
An' runes ...

Cobwebs in a drunken pasture
Hang hammocks made of silk
Caught rays of morning sunshine
Where the cattle sway with milk
Breaking strands fairy hands
The caravan of cow and man
Slowly cross fields they sink
In flooded lowland pans of ink

Drops of dew they splash
And break
And suddenly birds awake
In the glowing pink of dawn
Like pepper blown in

Swirling wind emotion
Flown in
Murmurations
Of what they-in
Their chorus-sing

The sun's aprisity
The daffodils like trumpet
Spills
Eye-like pills of iodine
Shaken in the rills of breezes
Wending in and outta
Roundabout
The greater scheme
Of things

Ripples spread
The moon's reflection
Across the surface of the
Stream
Easing pleasing in
Then weaving through ... a
Pleasure rising scented
Steam

The long grass
Where he lies
Is breathing
Living weaving

It is a prize worked
And laboured on
A replenishing
Carpeting

Dampened fur
With moistened dew
Soft the ground
Like plasticine
Moulded in a form
'Neath you
As the morning blew
Through
Their theocracy
Was waning
Dieing out
The nostrum
Medicine
Withdrew

Meddlesome the
Themes of spalpeen
Do ensue
Chains on gates
Distant curlew
Whiskers skew ears
Twitching
As if scolded
Nesting birds
Are emboldened
Wheezing and
Teasing too ...

110

And all these
Incidents and visions
Rolled up folded
Tied with string
Now undone
Escaping
Paper
Floating in the
Air
In reams

In a bachanal
Of powders whisked up
With a little cream
That cosy town
Upon the hillside
Where he's from
And where
He's been

Waxing shaking
Kicking
Waning whimpers
Re-emerging feigning
Simpers
In Crook's
Deepest
Dreams
Lain flat out
Beside the stream

The silent swan upon the lake
Slipping 'cross a misty screen
The bee fly hovering
Over him
When he was
First up on
The scene ...

FASTNET

A net
To the hunting one
I'm warning
Who am I?
Who you fleeting catch
Over there rub your eyes
By the Brierly patch
Suddenly I am gone
De-materialize
Along by the hedge and back
And off into the mist have flown
Along that disused railway track

Down the bending corridor
Of fluted columns climb
The bluebells
Incense and charcoal smells
Chime away time
A high church where
The incense columbines ...
Fastened to a railway line

Old train now stands at
Lands End empty
Going back a ghostly hoot
On its last legs belching soot
A plenty

Mumbling ...
Coz daylight's burning
The rock
And the light crack
Heavier than we ever thought
A'tumbling down its own steps
Is caught thinking blinking
Into the bubbling gurgling sea
The Fastnet Rock is sinking

LEMON KISSED

Sun hit droplets
Fine rain falling through the
Air and like a lemon marl
Light drizzle kissed the earth
Blew a citric blur
Drew lots of slanting yellow lines
Sliding down like frozen hair

And yet a nurse raising blinds
Alights the room in lemon rinds
Warned against sugar bakes still
Warm attracting nearby lakes
Where honey bees swarm flowers quake
So inclined spun sugar cocoons
Launched headlong into the room
An saw
The luscious cake

And winking at my 'complice friend
My willing wolfdane close
To fend a'peeling
Found glucose
And I find this cake sat plumply
On the quite white china plate
Strontium chromate bromate
A palette mixed my fate

Yellow spots on lemon leaves
Danced upon my eyes
If pressed cried tears of zest
Near a field of wheatsheaf
Sherbet cloud surprised
And there where the cake's now gone
My sworn promise now to break
Save where a few fat crumbs had sat
A lemon drizzle lake

I Am the Good Shepherd

I stroke his head
He sleeps
I hear the muntjac howl
I squeeze his ear
Feels like felt
I tease
I jump up before
He growls

Seventy or more odd kilos
His fighting weight
And if he had a wont to
He could leap up
And fell any man
But yet he don't
I am his mate

And yes I am a man now
It's taken me some time
This isn't what I dreamt I'd be
But they're my responsibility
And so so rewarding
For my time

As I wade through waves
Of autumn leaves
Through pools of
Dried out hollows
I kick great amounts as if
They're vagabonds and thieves

In an absent way
I stand and look out at the
Land my eyes follow in inches
Sloping away for however
Long the day
Their eyes stand watching
Follow
Mine

From my hand
A scimitar
I fling
A demagogic flirtation
With scare tactics
To bring forward spring
Persuade the reticent
Hiding birds
To sing

Like a boomerang of ideas
Where sang yellow
Hammer summer warblers
And coloured finches
It rises over cropped hedgerows
Spins and falls over strip lynchets
And as climbing swooping
Swallows do ...

117

I ruse
If the bible had been
Scribed by sheep
I would be their saviour
Receiver of their prayers
The hero of the keep
And still as the day colds
Bovid folds an my fowl must
Settle 'fore I can sleep
I wear the halo

I pare their outgrown nails
Of their ungrateful
Cloven feet
I watch over them through rain
Snow hail sleet
Chase worms
I tend to clear their 'New Forest eye'
And throw them meal and bedding
On the broken frosted ground
Ice cold set

Curl up near my hound
For the night gets hold yet
My crown now the milky way
Slips off ...
Wends above my weary
Darkening day
I am the shepherd of my flock
I must shock absorb them
At any cost from pests n prey
My eyes and mind
Are alert though
My body rests wintered
In pungent summer hay

My eyes reflect
The steely metal
Of the melting sky
In gimlet sockets roll
Be always bold
They have to ... at any cost
As too they sparkle early
With the morning frost

H.J.H
AKA LUCKY JIM

Tine courses a furrow ploughed through
The Strawberry Hill
A receding forehead drooping brows
Momentarily raised into a darkening sky
Which kisses heavy lids
School days gone by
Eyes lifted over to the side of time

Thoughts slipping ever into gravitas
A hand collapses down the clock face run
Your each way bet on the filly
11.30 Doncaster
Alas strolled in at 5 to 1

Should I ought to have had more children
Of my own?
Thought Jim
Ha hum ha hum!?

Yet in the baptismal register read out loud
That old schoolhouse bell sonorously sounds for
The great and good the
Many souls you have helped paternally
On through to adulthood
Rings through to ... "Ransome! Richardsons! Ridley! Southon!
Watson! Whelehan! Wiggins! Williams! Young!"
You helped to raise every one ... a mighty throng
Marvellous ... well done good effort you praised
Moonfleeting across a page
Of deleted lines ... our heads engrossed
You suffered fools

Behind those heavy lidded eyes
Flitting through the term reports
A modest reticence to predict the future trade
Plied by your pupils taught
Doctor Lawyer Teacher Farmer
Tycoon Banker Insurer Adventurer
Writer Journalist Mechanic ... Spy Artist
And Embalmer

Hodges! Cries God ... Headmaster of us all
You attended and completed your prep
Now carry on your worthy calling
Your gardens grown so well
But night is falling

Black curtain of your dusty gown
Flung back to rub out space
So you can chalk your epitaph upon the
Blackboard's face
Your work is done now
For this human race

A life lives ... soon lost
As we still left here must
Count the cost still earn our crust
Revolve some more around
Our setting sun ...
But you are gone

Dear Jim I thought I owned you
To myself
But now I look around
I realise of course
So did everyone here
And everybody else

IRON PROMINENT

Responding to a loud hail
Stormed a wail from a tree
A flag on a post the remnant 'rags of time'
I rush out an see
An alder bough in those strong wind
Yields gyratingly flaps away its fraudulent hold
In realisation ... it's too old
Clings a moth mahogany
So where will it land if it escapes its grip
Snaps gives way groans crashing tips
Wields its arm in a great circle
Dose the rotten branch
Falls sprawls across a winding stream
Bending rounds rounding bends
Like blocks of balsa floats
In sunsplashed gleam
Rolling slowly with the water's pace
Unravelling up stream coats of bark and pith
Stroke spokes of sunlight trace
Race downstream
As clouds of orange dust choke with
Spoken mute
Puff
Coughed
Descend dust clouds
On the waters face

On the mass now lodged
The cork-like
So softness but absorbs the water course...
Rails the floating sponge half submerged timber
Till it is coarseness stronger peels sheds
Until the harder heart remains only
Feels a hold lonely
Spans like its hands reached out
And caught a grip
Slips slides slows ... holds where
Some proud protruding tubers of flag iris grow

And steels into a groove within
The bank shakes shudders a-a-a-a-gainst the flow
Stuck deep it ploughs a keep
And there it rests
Becomes a bar a bridge
As if for ages it has
Been

Across insect caravans are seen
Trekking alighting like multicoloured bouncing beans
There ... lifting shifting
A shape one thought a broken piece of wood
Flights instead of fallen should
Iron prominent scuttles rests
Iron prominence lands melts into the form
Wedged ore
Spilt built like smelted helmet hue
Through to its bloody core
I take my hat off to you such camouflage
On the dot
Can do

Slits on a dead metallic star
Hovers a moth jerks into the air
Like a mammoth-coloured humming bird
Into a furnace raged and spilt spits
Almighty beats blasted in a steam
Cast smote smite an anvil might gleam
Moisture travelling in a droplet
Alights a foreign speck on your deck
From afar

Gnaws oxidising flaws
The ferrusbar into a stave
Steam hammered deep
Into a craw of naked steel
There moored evermore sheets flaking
From its bows a stern expression cord twists
Run along its folded wings
Giant hulk of silken shanks mist
Mass density ingrained run along its flanks
Groaning as it splits
Cracks implodes and shits into
Its very own
Where careering it crashes
Exploding shattered bits

Sulks it doves soft the hair about its collared head
Beruffed fluff de muffed
Begrudgingly cuts a figure out of powdered cloth
A shadow stain of its former Turin self
Wading through in a sea of mercury
Off Mercury's off shore shallows
On feathered legs
Creaking like a swinging gateway
Hanging from a gallows
In a vacuumed portal
Caught all atoms into this crusted form
Treads this a laaaaaaayered dusty worn iron filing path
Rests this moth sworn secret oath to wear it nests
Upon this rotten rutted shelf

THE OLD WHITE-HAIRED MAN

I heard the voice over the hedge
Now grown so high
I'd planted and never thought
I'd see grown fully
"So you want to keep
This old field Markie!?"

The voice I knew to be my friend
Old Crook was sat up on his lap
Like a human being
His aquiline suntanned nose
His shaggy white main of hair
He had become a person
But I did not care
He was smiling and laughing there
And static everywhere
Gripped the air

Yes I would I cried
It has always been there
And I think it should be kept
It defines all we've tried to do here
It would be such a shame to be left ...
Bereft of it

And all the while the friend and Crook
Together played
And he shook his magnificent white coat

And I noticed his swarthy suntanned skin
Against the brilliant white hair
They had become one
Sitting there

And when I returned from
Inside the house in jest
I tried my specs upon his nose
But he was how he used to be
And did not wake up from
Repose
In my mind's eye that adage
Let sleeping dogs lie

So I sat down before my desk
To write down this dream
Before it went away
A vision just before I woke
Before that voice had spoken

Yet into a mirror I now looked
There was that same white-haired man
Who'd cuddled my wolfdane Crook
And shook his mane
And I had now become myself
But I couldn't -though I searched
And searched
Discover any more
The more
Who the person was ... who
I was before

PINK AND BROWN EGGS BEARING

You couldn't miss it that late
Turning into silver plates
Reflected on the roof slates

A lemon sphere
Hovering near just over there 'n'
So weird I can see your face
When I shut my eyes
And contemplate superimposed
In its place
Around it an aura
Which eclipsed the lesser starlight
The moon creates a purple bloom
Which in the shadowed lairs
A fluorescence
Swirls of tousled hair ignited
Lights the gloom not unlike
Nor compromised in any way
Your golden hair made
Up in new array
Offset in a strawberry shade
Your face perfectly displays

And like the lunar set
To stir me like earlier yet
When you
Standing there
Burning ... thinks
I with pink and brown eggs bearing
Your eyes like this orb staring

129

Boring into my soul
But gently yet still
Watching every move I make
Intently

I felt an urge to touch your lips
My mind slipped retreating bent
Rejoined and tripped
Yearning leant
I fell into your green eyes
In an instance flipped a coin lands
In my metaphoric hand
The feeling died
Deciding me
I better went
Stealing off
Unsatisfied

Leaving in me
That familiar feeling
Of half content

CHARLOTTE AND THE BLACK CLOUD

Up the Long
And climbing street
Armed to the teeth
From the Market Place
With brassica and leeks
And some pies upon the way
And a cold wind at my back
Oh how the wind did blow today
And I had to agree with the
Man at the stall in hindsight
It's going to snow

Uneven paves below my feet
Uneven thoughts at play
I digested half my thought
And spat the rest away

And so the corvid cloud
Like nuns chase an exposed priest
Crept up and followed me
To the car
Billowed up into a
Threatening brow an awful
Invasive big black scar
And over Devizes it stretched
Out oh so high oh so far
How it grew
Like a cast of an erupting
Popocatepetl flu
To fall out on us all below

In a Wiltshire town at the
End of April
When it felt if it rained
It would surely snow
And the man at the market said
No asparagus today
Too early for that to grow

As my hound Crook looked out longingly
When are we going to go?
I talked with Charlotte Wooten ...
Now wooten you like to know
My heart leapt and looped the loop
And oh how it did grow
It lifted me up over the dark cloud
When I'd felt a wee bit low
From jettisoning half of my poetry works
From the next book on the row

And if you broke -
You coiling pyre which hovers over head
Charlotte's recovered from covid
And needs her garden bed
She's just shot off there in fact
To protect from impending slew ...
Her young and tender shoots
Like she they
Need some help to grow

132

And still Crook is waiting
To uncoil an aching spring
All I can say is she
Brightened the day
A gold glow aura round a ring
And Crook's no worse for
Waiting it was just a fleeting thing
He leaped out into the sleet
And rain unmoved
By the wet and sting

ARISE

Arise!
He rose
Grey bearded
And jagged at the flank a
Zigzag across the buttercup
Blanket where the swallow banks
Drank it
Sank it upto shoulder height
Draws up in a chaos
Of trembling shaking spray'n'
Tossed upto
Where a lark tumbles
Calling falling
In the cloud's wey
Out of human sight

Lurching the lanky haggard
Though noble descent
Cleft of lost
Hollowed lament
Lays out alas stretched
Drawn back into his mental
Reproachful look
Sedulous in application
Intrusive
His poaching nose to scent

ON
IN HONOUR OF UNCLE LESLIE

On in the spinning dream
The green
And twisted black I
Struggled still for
Consciousness but the
Dizziness fought on back
I felt my bottom jaw squash
Up into my head I was
Fighting with a writhing snake
As I bled swirling falling steeply
With the dragon in my bed ...

On on on once more
And all across the sea and land
Millions of human beings
Spinning singing where they stand
I am sweeping out a coat of butter
Levelling with my hand some gold
Filling in cracks and cataracts
My god this place is grand ...

And all that we look down on
From where a spitfire sits and
Eventually has to
Land on is where it all exists

Did anyone ever tell you
That when you spread your hand
The turf you grip rip hold aloft
This is old Ingle Angle 'and

KISMET
THE MONK'S DORTER

The monk inside ... me ...
On hearing the honeyed
Sweet notes of warbler
Falling as sugar quavers
In his dell retreat
Retired to his steppe dorter
Pulled down on his cell
His nighted blind
And all the starlight froze
Outside of his repose ...

An a belle chimed in a recess
The closest to a legacy
He'd ever leave behind
An enigmatic tinkle
From lost time...

It's all repair
In his dorter
Don't ask me why it oughta be
I need to sleep ...
Know the reasons too
Whispered in your ear
Nearby
There is no reasoning actually
There's the point now blunt
But nothing can be done
All's wore down an
Even the fun stunted
Shunted like the sun
Swallowed swirling by a black hole
Devouring everyone

The snookers are now
Veterans sub ceded by their
Better thans
And even if a sharp intake of breath
Is taken in a gasp
Through gaps of teeth
Nothing like the warping of
Our recollectioning
Mere insouciance
It's because something there
Is ...
Broken neath
Because it was made
It was meant to be
Deconstructed too
Like a Christmas tree
The bauble elements of
Happiness and glee
Hung next
The bristling needles
Irritations intent on grief
All taken down eventually
And put away
Carried out their brief brief
Too late
The Magi pray in vain
It's plain
It is the end mate
Fate ...
The sun's come out on
Kismet

THE MONK'S RETREAT

The monk's prologue
Monk's prelude
The monk's retreat
Somewhere in the
Fleece hotel bar in Gloucester
I find my feet

A pub in the village roster
Of Broadhemston Devon I meet ... A
Craven ...
Cacoethes loquendi
Flowing tongue
Leaving the original thought

Lost to every one
Talking to his self
In a schizophrenic way
Was what it took to
Get him through
The day

An'a belle chimed in a recess
The closest to a legacy
The monk
Would ever leave behind
An enigmatic tinkle
From lost time

His rosary interrupted
The cotton thread has worn at last
Snapped
Yet all is still caste
Sublime inside...
But
Outside his cell
The beads falling on the ground
Fell
Like exploding shells
The church bells swing
And bring the news to all
Around who dwell...

The monk unaware
Sunk in his old scratcher
The frost

His sunken well
Encapsulating his retreat
Greying his hair
Chewing on a crumb left
In his repast
Sun in patches brighten
His drunken soul
Contemplating his old feet
His only reflection
Of his self
Seen at the bottom of
His upturned washing bowl

And where he was
And what he'd meant to be
There
Went out the window
On a wing and a prayer
His manuscript of all he wrote
He sent to himself
With a short accompanying note
" If you can make
Head or tail of this
And it helps to make you see
The 'spoiled priest' I've been
Then
Wrap it up with your critique
And send it back to my publisher and
Me!"

ICE MAIDEN

I just remember how
They like to never forget...
The old folk from the woods
Who lived self-sufficiently in
Mud and wooden huts then
Down by the badger setts

How they used an
Old sheet of glass
To catch a reflection
Of their aged faces
All the time past
Caught mirrored there
Like a photograph
And how they used to ponder

For many were secretly fond
Of her...

Though cryogenics was not
A considered science then
How those beings who came
And went one time...
For they were real...
Shone like
The burnished wrought steel
Of a Viking's Ulfberht sword...

Made of ice so finely sliced
Grew they out of that
Frozen water near which
We hear in frosts severe

Unthawed
Like a glistening sparkling rink
Where the forest folk
Would routinely drink
And journey to to draw...
Would instead party long on
Heady honey mead wine
Sing stirring songs as they skated
And would eventually take time
As it lated
Over them a hush would come
As faces blushed
Fall quiet then to tell tales of old
And to think...

Appears the visitors
One winter
And graced the forests
Glens the Dingley Dells
And flooded wealds and fens

They called them ice maidens
Of female form it seems
And there was one
Whom was possessed of
An impish nature
And whose screams and laughter
Full of fun...
Who caught the hearts and minds
And indeed the souls
Of everyone

But she was of
Shone alabaster skin
So pure
They reckoned from afar...
Some even said she confided had
Visited from another star

And if
Your eyes are allowed
To wander up to
Orion The Hunter's
Twinkling belt
She travelled here in a
Thunder carriage...
But 't'was there she
Dwelt

ICE SEQUEL

It was one time...
And the children of the woods
Were playing rather late
As many parents had
Warned against and feared
They could
Somewhere near the centre
Of that frozen pond
When suddenly the ice
Gave way ... CRACK!
A young girl playing alone
At wizards and fairies
Waved her wand to spell and
With a helpless yell
Just disappeared

So cold
The ice reformed back over
Her to seal her fate
Down down
To a dark and watery end
She sank ...

The whole shire mourned
This tragic premature passing
Soon a great gathering
Carried wreaths ...
Dried flowers and herbs
In a procession wend
To meet the woodland folk
And lay them at the paths bend

She drowned without a trace
Too cold to last long
For if by chance
She had survived able to swim
Underneath in a pocket of air
Beneath the rock like ice
And make it to another shore
T'was more and worse
That might befall her there
For oft at night along
Prowled ulf and urse
The local parlance
For wolf and bear

While all were yet
Gathered
In a great throng
Cast down in remorse
In a lamenting song
A distant rumble
Grew into a mighty thunder
Suddenly like meteors
Falling from the sky a
Phalanx of shining
Silver ice angel creatures
Flew down from above
In a flaming course which
They managed to extinguish
As they landed nigh ...

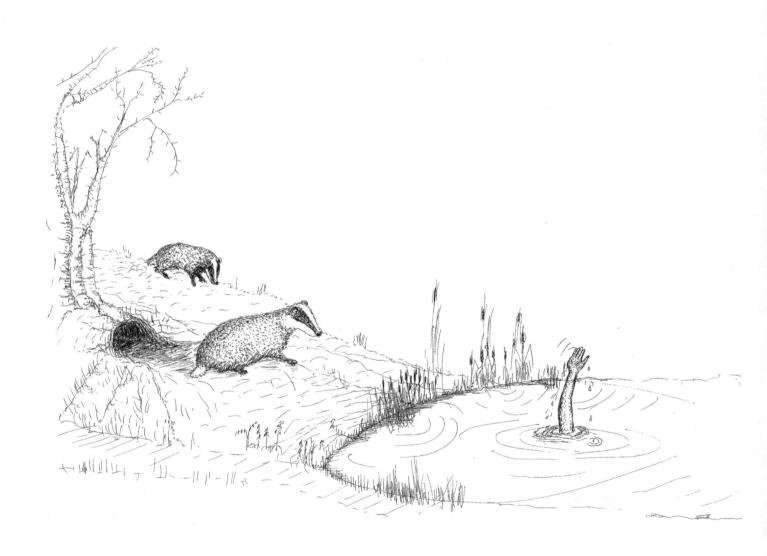

And...
There she stood before them
Tall and astoundingly beautiful
But majestic now...
And gone they noticed
All that madness and impish
Lairiness of her youth

She gave a command and waved
A clearing in her followers bands
And a way too through
Their lowly ranks
And with such sudden
Innate grace and alacrity
Leaped high in the air
Dove down in doing
Smote the thick ice surface
Into smithereens then swam
Fathoms deep about
Where that poor young child
Had uttered her final shout and
Was last seen

A mass of bubbles and
The water seemed to churn
Up through the surface
She exploded returning
Unharmed and loaded
With the ashen child
Clasped in her burning
Strong white sparkling arms
Kissed her mouth till the stiff
Form relaxed stirred smiled

In a peaceful sleep
To the villagers shocked
Expressions of relief
And disbelief

She looked down to all the
Silenced crowd who looked
Back up to her with
Astonishment and awe
She laid the infant by its
Parents side and pressed
It ever so gently more
On its chest and eyes

The child awoke to grateful cries
And then she blessed it
Spoke something strange
Waved her throng to leave an' go
With one last long look back
To the woodland folk
Her eyes shone
Like a diamond star

Loasting there
The coolest
Ultimate form of chill
Stood stock still she
As if in meditation...
Tall and bright then
Took off and in a shower
Of snow and splintered light
Was gone

As Is ... An Orange Tip

Orange Tip
Eyelash
Brush a feather on my lip
Sip
Fox glove slippers
Glides the butter
Flutters o'er
My window sill

Now cruel frosts grip the stems you clutch
Weeping fallen crouched and bent
Blackened flora hugs the ground
Icy filaments of sound
Cover everything
Around

In trances stunned
My fingers numbed
Will not work or bend to
Count
And all the days
To go
Without you late
Orange tips and white about you
Green veins tightly tick
In your Cryonic
Stasis
Curled up below
An overhang
Retired wound up

Unworking sleeping
Ready to emerge
With wings
And shock us all
Again next
Spring

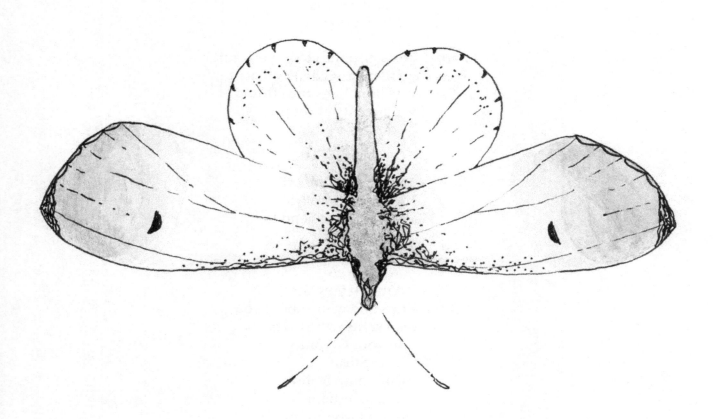

ORANGE TIP TWO

Shadow of a green veined
Flannelette
Flapping over the solar
Panel
Silhouette

Lifts gently wing of orange
Tip
Alights upon my face to kiss
My lip
Under the peartree blossoms
You have lately sipped
Gently bruised but not
Abused there
Where
Drip their honeyed
Pipettes
Condensed
In saturated
Viscous thundery
Air

An airborne petal
Without a sound around
Around you spiral
In turning loop until
Aground amongst
The dark retreat of nettles
A forest distilled thicket musk
Of jagged emerald metals

Shone luminescent at dusk
Where in their shadows
You recoup
I stoop to look for you
But you are gone ... you
Fade ...
Again
The process
Is maintained

I have slipped into a slumber
By the shade I sit
When I awake will make
Amends taste the
Cool lemonade of
Summer's beginning and
Spring's end which prelates
Your soon departure
Sweet butterfly and my
Ephemeral friend

QUIETLY THEY GRAZE

Quietly they graze by the Folly Wood
Ghosts are near which linger here
The cattle behave as Christians should ...

These spirits take flight at night
Like the pipistrelle
And longeared bats
That flit like
Nocturnal butterflies weaving
In and out the woods nearby-
Arboreal acrobats

On these incipient hours of summer days
Buttercups hold and retain their dew
As golden chalices and
When sprinkled with a little rain at dawn
Are magicked into such
A silken brew

They sip through their stride
These darling harlequins
Topping up
The milken churns that
Sway between their tired
Dropped hind quarters swing
Low slung
To and fro ring true
As the bells in the
Neighbouring Potterne Church
Far off below still do

The morning mists lift misfits
The sun burns through
And if a few drops are spilled
From their engorged udders
Then the foraging hedgehog will oblige ...
All day the dairy factory slaves munch on ...

By evening all has melted to a slowing pace
Like honey from its wax comb
When breathed on barely flows
And kissed with grace bestowed
The piebald matriarchs simply sink down to doze
And bring their lows to a close phased ...
Just echoes now in a dusky haze

A single whisp of a cloud
Falls into a purple streak
Heralds the dying day
Slips off the edge of the earth
And into the depths of molten sea

Slides the sun like off silent
Hot crossed
Buttered buns
Off their sweated flaxen crops
And down their flanks
And scarlet shanks
They now sleeping nod

Slips with those pastoral echoes
To the very sod they together
Simultaneously
Sight and sound run aground
Pan across below the cooling meadows
And back up the greensand cliffs
Off into a sky of aquamarine...
Then up aloft
With thanks to God

ALL VERY FINE

Approaching the wood
A murder of crows arose
Raucous and irate
A confusion of guinea fowl
Scuttled by
A peacock howled
Posed on a moss green gate
And now and then in glades
And gaps between yole trees
Like on a cottage wall old oil paintings
Appeared
A breath held glimpse of
Pastures where cows dozed

All very fine to meet
Within my mind but
Unexpectedly exposed
In real prose
Almost unbelievable that
Such oases persist
And just to cap it all
Not to be out done
A yellow hammer up a
Drying puddled track lisped...

Out poured the currant bun
Licking everyone
Seering exploded dazzling
On the run running
Roughshod over everyone

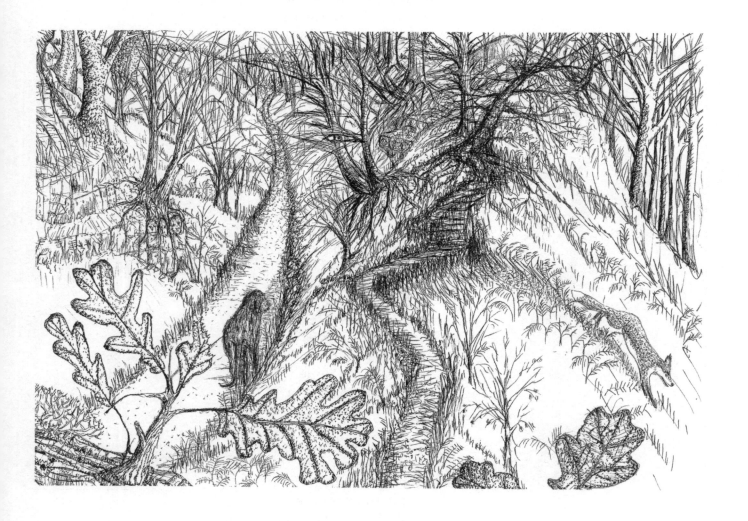

I woke with the customary jolt
And tasted my tongue
Up too late ... pissed
So this is Wiltshire
This is Pewsey Station almost
Missed
I gave the earth a great kick
Dust flew and tasted
Rather fine... dull sherbet mixed
With altar wine
Manufactured by the tine
This is Devizes
This is Potterne Wick
This is Crookwood
My orchard
Where my life exists
And this is an old discarded
Piece of brick
As proof
Near the beginning of it

I PREVAIL

I prevail in Crookwood Vale
Picus veridus
Above I sail
I am a simple green
Woodpecker
Sometimes I win sometimes I fail
I
Do not see what approaches me
So fast I hurtle grass to tree
For gravity one has to beat

And no one else watches over me
When sure the night falls
Sometimes grim
I fall to sleep I think of him

One time exploding from a tree
Which is my wont
I aimed my fuselage at a distant
Spartan apple tree
Where even in this great freeze

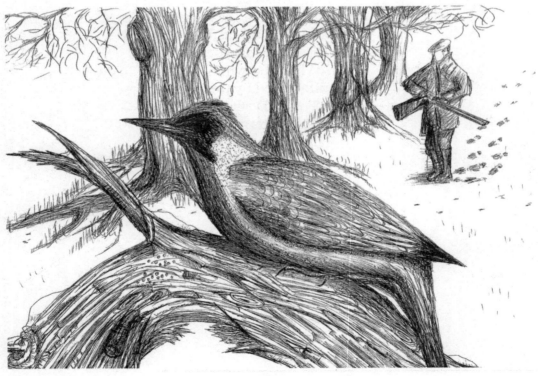

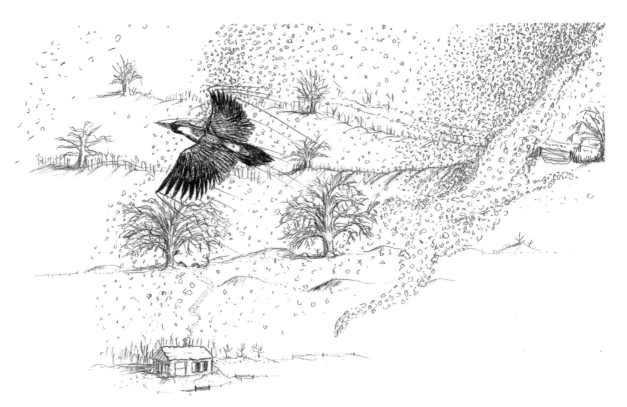

A hearty meal reserved for me
Dark clouds falling thick did blow
When suddenly by my side
Then past my rear
A fast-approaching U.F.O.
Did slide
My fiery plumes consumed
With fear for
Through the flurried flakes
Below left and right

The ghostly spectre swept
He wove a figure
Made of snow ...
Where he came from I don't know
Nor do I know where he
Did go ...

Yet I see him in my mind
A'glow
Falling

TO EXTRAPOLATE A THEME

To extrapolate a theme
Across the fields glides a creature
Fine form and features
My eyes can't help but follow
Leach her looks her
Bountiful bosom
Hooks...

Man the vessel here's the scene
Queuing up lactating teams
Bursting out their udder seams
Engorged and gently jostling crowd
Like dark underbellied cloud

Herbivores quenching thirsts for green
To magic into churning cream
Where whey suds fizzle
On the top
Condensed drops of air now
Stream

That scent of motherhood
Non stop
Still warm from mopping up
Their lot
Fields of daisies dandelions
Nettles clover grass and
Buttercup

And always they make me smile
Stopped resting at gate or stile
Admiring that bucolic view
Incomplete without its crew

Yet the lady I admire
Who I muse on who inspires
Sees no beauty in the beast
Ignoring this wax lyrical piece

For she was chased across a field
When an infant and still feels
Antipathy and in her fear
Wild horses wouldn't drag her near

And so to metaphor equation
Nonsense to employ persuasion
Or to linger or to pause on
One man's meat's
Another man's poison

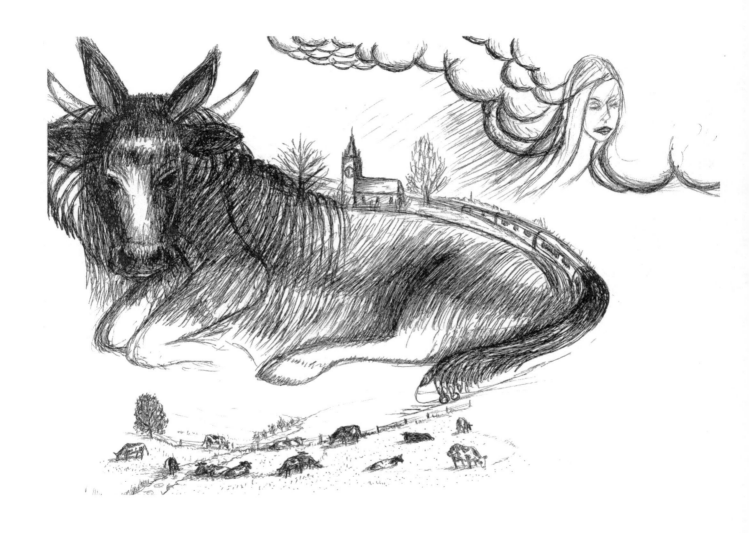

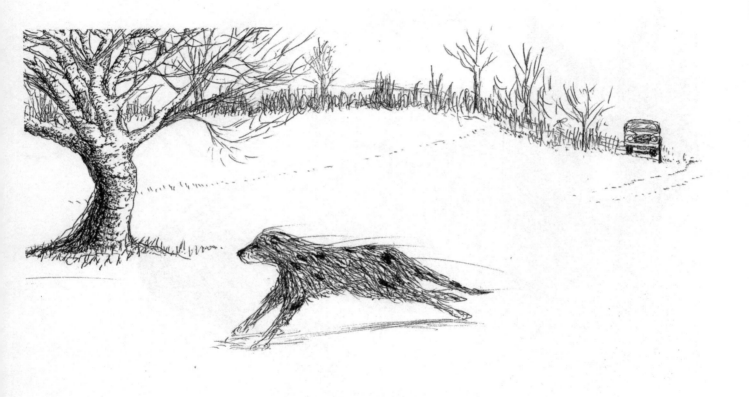

TOMORROW TOO

And in the morning
When I got up
Reticent to open the kitchen door
Where inside he took his repose
Sure enough
Instead of his warm eagerness
Those deep searching eyes
And furiously wagging tail
He was not there
On a whim … he had taken off
Somewhere

Cold to touch
His tousled bed
I mimed a pat an stroke
Upon his head
Inert
A stillness on the floor
So alien
That mad incredible
Irrepressible animated
Blue merle hound
My best and dearest friend
And more

SOFTLY THEY CHEW THE CUD TOO

Settled in sweet-
Sombre pasture slung
In pungent lush green sprays
Are hung plangent prayers
A suspended plongeant
Ambience...

Prolonged
Silence ...

Stock-still they sleep
As sculptures would
Only their ears flick click
Kinetically
Invasive flies buzz away along
The river eccentric

Their shadows with them bide
When up and stood
Their tongues hide churn inside
Out their mouth barely open
Occasionally a cough
From off and ... then ...

Softly they chew the cud
Lisping poems on the flood
The tide flows in the tide
Ebbs out ... as a life blood

Black and white as clear cut
Thoughts scatter in bluffs and
Waved redoubts
Whereabouts
Buttercups stud the green pasture
River berating lustre

Full brimmed racing milk
And custard
Gloating words passing muster
Highlight in
A gilt-edge sunset sinking
In deep waters shrinking thereabouts
Someone swimming...
Floating thinking

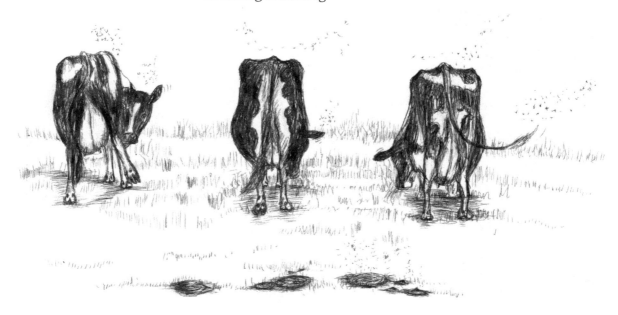

COMING SOON

SATURN SLIPS
ITS RINGS